Contemporary Anthology
of Music by Women

Contemporary Anthology of Music by Women

EDITED BY
James R. Briscoe

INDIANA UNIVERSITY PRESS
Bloomington and Indianapolis

Publication of this book is made possible in part with
the assistance of a Challenge Grant from the National
Endowment for the Humanities, a federal agency that
supports research, education, and public programming
in the humanities.

Publication of this book was also assisted by a grant from
WISP (Women in Scholarly Publishing), Indiana chapter.

Cover illustration incorporates *Rotation* (1994), by Barbara Heller
© Furore Verlag, D-34127 Kassel, Germany
ISMN M-50012-050-6

© 1997 by James R. Briscoe
All rights reserved

No part of this book may be reproduced or utilized in any
form or by any means, electronic or mechanical, including
photocopying and recording, or by any information storage
and retrieval system, without permission in writing from the
publisher. The Association of American University Presses'
Resolution on Permissions constitutes the only exception to
this prohibition.

The paper used in this publication meets the minimum
requirements of American National Standard for Information
Sciences—Permanence of Paper for Printed Library Materials,
ANSI Z39.48-1984.

Manufactured in the United States of America

Cataloging information is available from The Library of Congress.

ISBN 0-253-21102-6 spiral

1 2 3 4 5 02 01 00 99 98 97

Contents

FOREWORD BY SUSAN C. COOK ... ix
PREFACE ... xi

Emma Lou Diemer ... 1
 Fantasy on "O Sacred Head" (1967)

Elena Firsova .. 12
 "What has caused my heart to feel songful," from *Three Poems by Osip Mandelstam* (1991)

Jennifer Fowler .. 17
 Blow Flute: Answer Echoes in Antique Lands Dying (1983)

Sofia Gubaidulina .. 25
 Garten von Freuden und Traurigkeiten (1981)

Barbara Heller .. 43
 Tagebuch für Violine und Klavier,
 Teil II: Die Linien, Movements I and II (1986)

Adriana Hölszky ... 50
 Hängebrücken I und II: Streichquartett an Schubert, excerpts (1989/90)

Betsy Jolas ... 60
 Plupart du temps II (1989)

Barbara Kolb ... 71
 Millefoglie, excerpt (1985, revised 1987)
 Voyants, excerpt (1990)

Joan La Barbara ... 97
 "to hear the wind roar" (1991)

Libby Larsen .. 107
 How It Thrills Us (1990)

Hope Lee 119
 Tangram (1992)

Nicola LeFanu 130
 The Old Woman of Beare, conclusion (1981)

Tania León 155
 Momentum (1986)

Alexina Louie 164
 "Ritual on a Moonlit Plain," from
 Music from Night's Edge (1988)

Elisabeth Lutyens 179
 Plenum I (1972)

Babbie Mason 188
 "Standing in the Gap for You" (1993)

Joni Mitchell 195
 "Hejira," from the album *Hejira* (1976)

Meredith Monk 202
 "Airport," excerpt from the opera *Atlas* (1991)

Undine Smith Moore 221
 Mother to Son (1955)

Alice Parker 229
 "Lethe," from *Songstream* (1986)

Dolly Parton 236
 "Coat of Many Colors" (1969)

Marta Ptaszyńska 241
 "Thorn Trees," Movement III, Tema con 7 variazioni,
 from *Concerto for Marimba and Orchestra* (1984–85)

Shulamit Ran 260
 Symphony, Movement II (1990)

Jean Ritchie — 281
"The L and N Don't Stop Here Anymore" (1963)

Lucy Simon — 284
"Come to My Garden," from *The Secret Garden* (1993)

Natalie Sleeth — 289
"Hymn of Promise" (1985)

Grace Wiley Smith — 292
A Distant Dream (1995)

Joan Tower — 296
Night Fields, for String Quartet (1994–95)

Nancy Van de Vate — 319
Chernobyl (1987)

Judith Weir — 354
The Consolations of Scholarship, excerpts (1985)

Gillian Whitehead — 374
The Journey of Matuku Moana (1993)

Mary Lou Williams — 387
"Our Father," from *Mary Lou's Mass* (1969–71)

Judith Lang Zaimont — 396
Parable: A Tale of Abram and Isaac, excerpt (1986)

Foreword

The last decade has witnessed nothing less than a paradigm shift in the way we view music history and how we teach it. Responding to the aims of the women's movement of the 1960s and its scholarly outgrowth in the discipline of Women's Studies, music historians, performers, and audiences began to ask a seemingly innocent question: "Where are the women composers?" Answering the question proved both frustrating and exhilarating but ultimately created a new subfield in musicological studies focusing on women in music.

In a desire to provide all students—male and female—with role models of creativity, James R. Briscoe has been helping to answer questions concerning women composers in an especially constructive way. His groundbreaking *Historical Anthology of Music by Women* (1987) provided a much-needed antidote to music history texts that reflected a past in which women were relegated to passive roles as muses or helpmates but were rarely, if ever, presented as active creators or shapers of musical culture. His anthology presented fifty-one works by thirty-seven composers that ran the gamut from Byzantine chant of the ninth century through 1980s symphonic repertory. Many of the compositions in the anthology had been inaccessible prior to this publication. Augmented with discussions by noted scholars in the field, the *Historical Anthology of Music by Women* provided students with ample proof of women's creative energies as well as the varied and changing social contexts and constraints under which they worked. This widely used anthology is now a core text in music history courses and has provided a basis for countless women-in-music courses, which have become increasingly common on campuses across the country.

The *Contemporary Anthology of Music by Women* continues the work begun in the first anthology by focusing on work by women composers written within the second half of our own century, a century in which women around the world have made enormous gains in the struggle for self-determination and equal access to power, both political and artistic. In the United States the suffrage movement of the late nineteenth and early twentieth centuries not only earned women the vote, but sparked far-reaching discussions about women's role and place in society. During this time, many women gained a greater access to education of all kinds through the establishment of settlement houses, women's colleges, and increased support for coeducation at public institutions—especially land-grant universities—whose mission was to offer higher education to children of the working class. No longer was an educated woman an aberration or someone to be feared.

Although women still faced many barriers, not just of sex/gender discrimination, but along race and class lines as well, we see a dramatic flowering of female participation in musical culture as the twentieth century continued. Women became increasingly public in their activities and even outspoken in their calls for recognition and change. Knowledgeable "matrons" of the arts like Elizabeth Sprague Coolidge used their financial wherewithal to promote musical ensembles and organizations as well as to support the careers of individual performers and composers. Female performers

no longer faced the social censure that had previously accompanied appearing in public. Women like Marian Anderson, the first African American to perform at the Metropolitan Opera, confronted and overcame further barriers to their full participation as performing artists. Young girls and women whose own muses guided them to composition could now find access to the musical training that had been previously off-limits or difficult to obtain unless they came from musical families. Even more important, trained composers, such as Undine Smith Moore and Libby Larsen, found the support of performers, conductors, patrons, ensembles, foundations, and scholars essential to making their works come alive and ensuring that they would continue to be heard in the public realm.

While earlier women composers, including some presented in the *Historical Anthology of Music by Women*, were often limited to genres deemed "ladylike," such as songs and solo piano works, the greater availability of musical instruction fostered women's contributions to all musical genres. While women continue to write songs and solo piano works, the *Contemporary Anthology of Music by Women* shows that women now cultivate all genres of modern music-making—from the symphonic work of Shulamit Ran to the operatic compositions of Judith Weir, to the chamber music of Adriana Hölszky, to the avant-garde contributions of Joan La Barbara.

Particular strengths of this current volume are its breadth and its chronological specificity. The thirty-three composers represented come from a great variety of ethnic and national backgrounds. Some composers, like Joan Tower, may already be well known to students; others, like Polish composer Marta Ptaszyńska, may be unfamiliar but are no less deserving of attention. The thirty-four compositions included span the years 1955 to 1995, with the majority coming from the 1980s and 1990s and thus providing a compelling view of the number and diversity of recent works by women. Most of the composers are still alive and actively shaping musical culture not only as composers but often as teachers, performers, and conductors. Thus, students have the wonderful opportunity to learn about such composers as Tania León, Sofia Gubaidulina, and Meredith Monk, whose careers they can continue to follow as the century draws to a close and a new millennium begins.

A further example of the collection's breadth is the inclusive way Briscoe has defined composition. While works from the canonic concert music tradition—what is typically called "classical music"—are central, he has also included works from other genres typically not found in textbook anthologies. The farsighted inclusion of works by Joni Mitchell, Dolly Parton, Lucy Simon, and Mary Lou Williams, coming from popular and country music, musical theater, and jazz, show the ways in which women have been active throughout musical culture. To limit the focus of this anthology to concert music would limit our understanding of female artistry as well.

The *Contemporary Anthology of Music by Women* will, like its predecessor, become indispensable in music history classes. Picking up where the earlier anthology left off, this new collection provides compelling examples of current female creativity. Its presence in the classroom should render it impossible for any student to be without role models or to wonder, "Where are the women composers?" While the *Historical Anthology of Music by Women* answered that question as regards the past, the *Contemporary Anthology of Music by Women* responds to it for the present and provides a cogent context for the future.

Susan C. Cook
The University of Wisconsin–Madison

Preface

This *Contemporary Anthology of Music by Women* addresses a need not fully satisfied by its predecessor, *Historical Anthology of Music by Women* (Indiana University Press, 1987). There the aim was to show the spectrum of women's work as primary creators of music across the centuries, from chants written by the Byzantine nun Kassia in the ninth century to the 1982 *Symphony No. 1* of Ellen Taafe Zwilich, the first composition by a woman to receive the Pulitzer Prize in Music. In the present anthology, the aim is to illustrate the exponential increase of that creativity since about 1970 in the Americas, western Europe, eastern Europe, Asia, New Zealand, and Australia. One finds with contemporary women composers a flourishing by a previously repressed group quite unlike anything in the Western arts since the emancipation of European Jews after 1800. It is observable in a multitude of idioms, from jazz to contemporary gospel, folk, concert, and experimental music. The new, powerful wave of composition by women exhibits perspectives ranging from the simple, popular, and nature-oriented to the abstract and complex.

When one observes this long-awaited outpouring, can one identify signs of what distinguishes the woman's voice in composition? The present emancipation is still young, and many more examples of music by women will be required before an overview of essential gestures may be argued convincingly, if ever it may. Whether these gestures are innate or are learned through socialization, and even whether the process by which they are present in the woman's voice is significant, may not yet be determined. I nevertheless state that women are notably intimate and intuitive communicators through music. They are more often given to a statement that is concrete, whether nature- or person-centered, and often they address the human condition vis-à-vis political structures or the environment. Formally, women tend toward recurrence and structural interrelationship rather than a nonreferential, open process. The force of their composition is often concentrated on giving voice *immediately* to the emotional moment. And yet, this tendency is most powerful in its cumulation, as many a woman composer compels the listener to *feel* across a broad time span.

Two sources are important for users of this anthology to have at hand: the *Norton/Grove Dictionary of Women Composers*, edited by Julie Ann Sadie and Rhian Samuel (1994), and *Women and Music: A History*, edited by Karin Pendle (Indiana University Press, 1991). A complementary source is the *Historical Anthology of Music by Women*, mentioned previously. Further information on the composers represented here may be found in these sources.

In most cases, the composers themselves provided the essential insights of this anthology. They were asked to recommend the scores that represent them and were sent questionnaires to which they might respond. Issues on which the composers commented included their professional development, reflecting on both obstacles and encouragement; differences they observe between women and men as composers, whether of training, socialization, or tendencies; how each one hopes to be viewed; the genesis, structure, and meaning of the work at hand; and its performance and

reception history. Whether offered in direct communication or quoted from previous writings, their reflections on these issues figure prominently in the essays that follow.

This anthology owes its existence to the many women who permitted their compositions to be included, although receiving no material benefit, but typically for the sake of nurturing male and female students and scholars toward a more-complete perspective on today's music. It has benefited a great deal from the advice and encouragement of Austin Caswell, Susan Cook, J. Michele Edwards, S. Kay Hoke, and Joan Tower. Moreover, I received substantial help from my institution, Butler University, in the form of a grant for preparation of the anthology. The music librarian at Butler, Holly Borne, offered excellent and generous assistance. My greatest appreciation is reserved for Anna, my wife, whose depth and span and unshaking sense of relationship keep reminding me of the roots of this celebration.

I dedicate this collection with admiration and affection to five main players in the study and teaching about women composers, whom Willa Cather seemed to foretell in *O Pioneers!*

Adrienne Fried Bloch
Edith Borroff
Karin Pendle
Nancy Reich
Natalie Wrubel

Her lantern, held firmly, made a moving point of light along the highway, going deeper and deeper into the dark country. . . . She had never known how much the country meant to her. The chirping of the insects down in the long grass had been like the sweetest music. She had felt as if her heart were hiding down there, somewhere, with the quail and the plover and all the little wild things that crooned or buzzed in the sun. Under the long shaggy ridges, she felt the future stirring.

Indianapolis
April 1996

Emma Lou Diemer

(*born 1927*)

A native of Kansas City, Missouri, Emma Lou Diemer recalls in correspondence that her

> earliest collection of short pieces were written down by my teacher when I was about 7. I was a very active young child, and had many interests in the early years, but did determine to make composition my life goal by the time I was about thirteen.

She encountered many models and sources of inspiration in her formative years, but does not single out any one for special prominence.

> The music I heard and played was the most important influence on me. In high school and beyond I played and listened to a great deal of music (my whole family was particularly musical): Brahms, Schumann, Bach, Gershwin, Cole Porter, Prokofiev, Grieg, Tchaikovsky, Shostakovich, Schoenberg, Khatchaturian—his *Toccata* for piano "turned me on" to color and excitement in music. . . . I found it much more exciting than Mozart and Haydn! Russian music was a great influence from then on. Every valued teacher, every performer, every encouraging family member and friend is a mentor, and I had many of these.

Emma Lou Diemer earned her bachelor's and master's degrees in music at Yale University, where she studied composition with Richard Donovan and Paul Hindemith. She earned her doctorate at the Eastman School of Music, studying with Bernard Rogers and Howard Hanson. A Fulbright Fellowship permitted her to continue composition study in Brussels at the Conservatoire Royal. In 1954 and 1955 she worked with Roger Sessions and Ernst Toch at the Berkshire Music Center.

As of this writing she continues her service to music as a church organist in Santa Barbara, having retired in 1991 from the University of California campus there. Previously she was professor of theory and composition at the University of Maryland. Her style encompasses many idioms, according to J. Michele Edwards, in the *Norton/Grove Dictionary of Women Composers*, ranging from serialized pitch content and rhythm, in *Declarations* (1973) for organ, to extended instrumental techniques, in the *Variations for Piano, Four Hands* (1987), where piano interior playing is used. Diemer has explored new avenues of tone color, as in her Trio (1973), for flute, oboe, harpsichord, and electronic tape. Tonal idioms predominate in her music, although her tonal sense is often rather extended.

Diemer has composed for many performance media and purposes: religious and secular works for solo voice and piano, organ, and chamber ensemble; organ music; harpsichord works; pieces for solo piano, piano duo, and piano duet; compositions for carillon and for percussion; guitar music; and a wide variety of choral pieces *a capella*, with keyboard, and with orchestra. She has an express purpose to compose for an array of performing venues and skill levels. Her *Three Mystic Songs*, on ancient Hindu texts, for soprano and baritone with piano, was written for the capacities of artist performers and was premiered by Peggy and Jule Zabawa at the National Gallery of Art in Washington in 1963. The need for a new, advanced literature for colleges and conservatories also attracts her attention: *Piano Suite No. 1* was composed in 1947 on T.S. Eliot's "Landscapes" for the Student Composers' Symposium at the New England Conservatory. Similarly, she writes for a university audience in *Invocation* (1985), for chorus and orchestra, which was commissioned by St. Lawrence University and published by Carl Fischer. Diemer composes readily for high school groups—in the choral work *Outburst of Praise* for the schools of Arlington, Virginia; and for churches and entire denominations—the anthem *Praise the Lord* (1975), for the Lutheran Church in America. Professional music associations likewise have commissioned works from her: *Reflections from the Tower* (1990), for carillon, was composed for the Guild of Carillonneurs in North America; and *Four Poems by Alice Meynell* (1976), for high voice and chamber ensemble, was written for the professional music sorority Mu Phi Epsilon.

Responding to the questionnaire about women as composers in the 1982 *Perspectives of New Music*, Emma Lou Diemer noted that

> I think I have developed something distinct in my way of composing music [as a woman], and how can I escape from being known down through history as a "woman composer"? I will be rather proud of it. But also, it will be nice to be thought of as a "person": "Diemer," who wrote music. The more we know about women who write music, the more of their music that we know, the better-informed we are. I can remember well that a few years ago the only names I knew of women composers were Clara Schumann and . . . myself.

In a recent communication, however, she noted that her experience in higher musical education was no different from any other aspiring composer:

> I was confident in my writing and considered myself a composer (not a "woman composer"), and was treated as such. I cannot remember anyone using labels at that time, nor any discrimination toward me taking place at Eastman or Yale (although there were few women composition students and no women on the composition faculties).

Regarding any outright disparagement that she encountered as a woman, she replied to the 1982 questionnaire,

> I have never been told that I drive like, throw a ball like, compose music like a woman. I would prefer to have my music on a concert of old and new music written by females and males and listened to by a mixed audience (female, male, old, young).

When asked to assess the personal experience of composing, Diemer answered,

> If composing is a difficult, isolating, complicated way to choose to spend one's life, it *has* to be easier for a man to choose it, not only because of his conditioned temperament, but because he could spend long hours composing while someone else took care of the practicalities of life. This has been the case in every field of endeavor.

In her personal communication, Diemer finds no differences between the way a woman and a man approach composition.

> We have all the same general education, talents, goals. I see no "differing emphases." Men, as well as women, can fall into the trap of composing easy pieces for piano or easy choral music. If this is not one's goal, one should make sure that one's reputation does not rest on that.

Emma Lou Diemer calls to our attention that her music contains elements of popular and folk music, jazz, and so on. It is

> music with rhythm, melodic interest, color, structure. I am also interested in innovation, and have worked in the electronic and computer media for many years. . . . I find academic (soul-less) complexity just as stultifying as mediocre (and soul-less) simplicity. I would like to be viewed as a prolific, eclectic composer for many mediums and on many levels of difficulty who was interested in writing music that appealed not only to herself but also to a wide audience.

Fantasy on "O Sacred Head" (1967), presented here, is based on the familiar Passion chorale. It was composed with herself as performer while she was serving as organist at the Lutheran Church of the Reformation in Washington, D.C.

> The opening tremolo is a burst of pain, a "cry!" and is followed by the *first phrase-motive* of the chorale, varied rhythmically and in parallel seventh chords (omitting the fifth). Statements of this motive are heard in the left hand and then in the right, and become sixteenth-note patterns, which begin softly and crescendo cadenzalike with a variation of the *second phrase* of the chorale heard in the stepwise motion of the top voice. The climax of this section is the "cry" again, with tremolo in the lower voice and the descending *first phrase-motive* above.
>
> The dynamic softens, and a faster figuration in the left hand accompanies the *third* and *fourth phrases* of the chorale in the right hand, rhythmically altered, and with the notes separated by rests. The expression becomes more lyrical, though in the same restless tempo, with the *fifth phrase* of the chorale in imitation between the right hand and the pedal in sequence. This diminishes to another slow crescendo using the *first phrase-motive* in variation between the hands and pedal (each one in different rhythm), climaxing in the tremolo "cry," and proceeding to the *fifth phrase* of the chorale in imitation between the top voice of the right hand and the pedal and rapid sixteenth-note patterns. At the fortissimo the *fourth phrase* again is in the top voice in sequence. There is a diminishing to a six-note ostinato in the right hand and the *first phrase-motive* in two-part imitation in the left hand, slowing in time and duration. The final "cry" is heard *fff* with the tremolos, the *first phrase-motive*, parallel seventh chords, and a ninth in the pedals.
>
> What does the work mean to me? It was written not only for the Lenten season, specifically for Passion Sunday, but also in remembrance of a dear friend. At the time, the chorales of the church had become a source of much musical inspiration, particularly this one, which was originally a love song, as were a number of the Lutheran chorales. One of the first times I played it was for a Passion Sunday service, and it was preceded by a poetic, dramatic reading on the Crucifixion.

Emma Lou Diemer has been recognized widely for this composition in reviews and by multiple performances. Her several, notable compositions for organ and sixteen published collections of hymn settings resulted in her having been chosen as Composer of the Year in 1995 by the American Guild of Organists. Another major

recognition of 1995 was the Award of Merit from Mu Phi Epsilon, an international music fraternity.

Bibliography

Barkin, Elaine, compiler. "In Response" (a questionnaire to women composers), *Perspectives of New Music* 20/1–2 (1982–83): 311.

Fantasy on "O Sacred Head"

Emma Lou Diemer

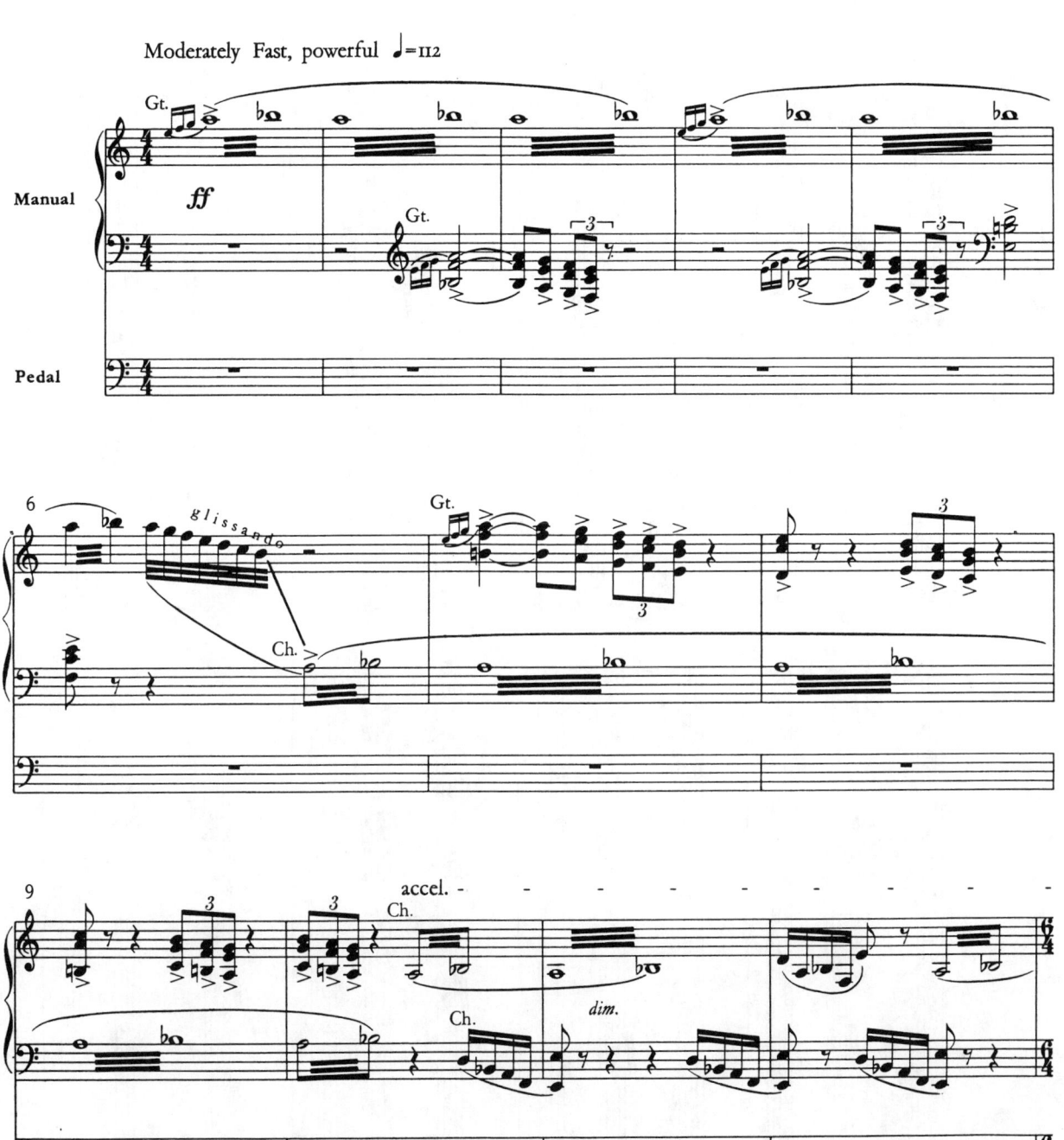

© Copyright 1970 by Boosey & Hawkes, Inc. Reprinted by permission.

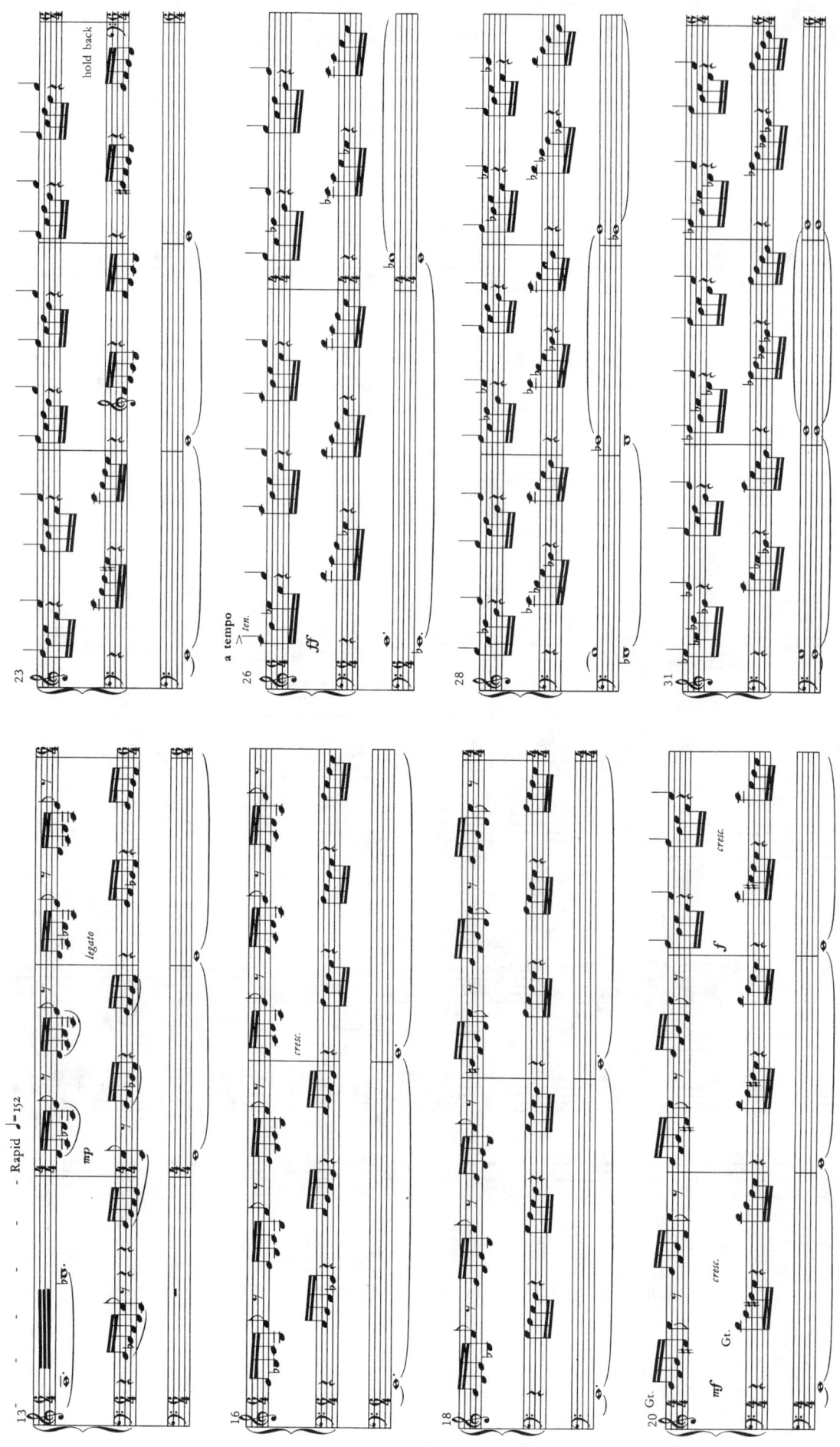

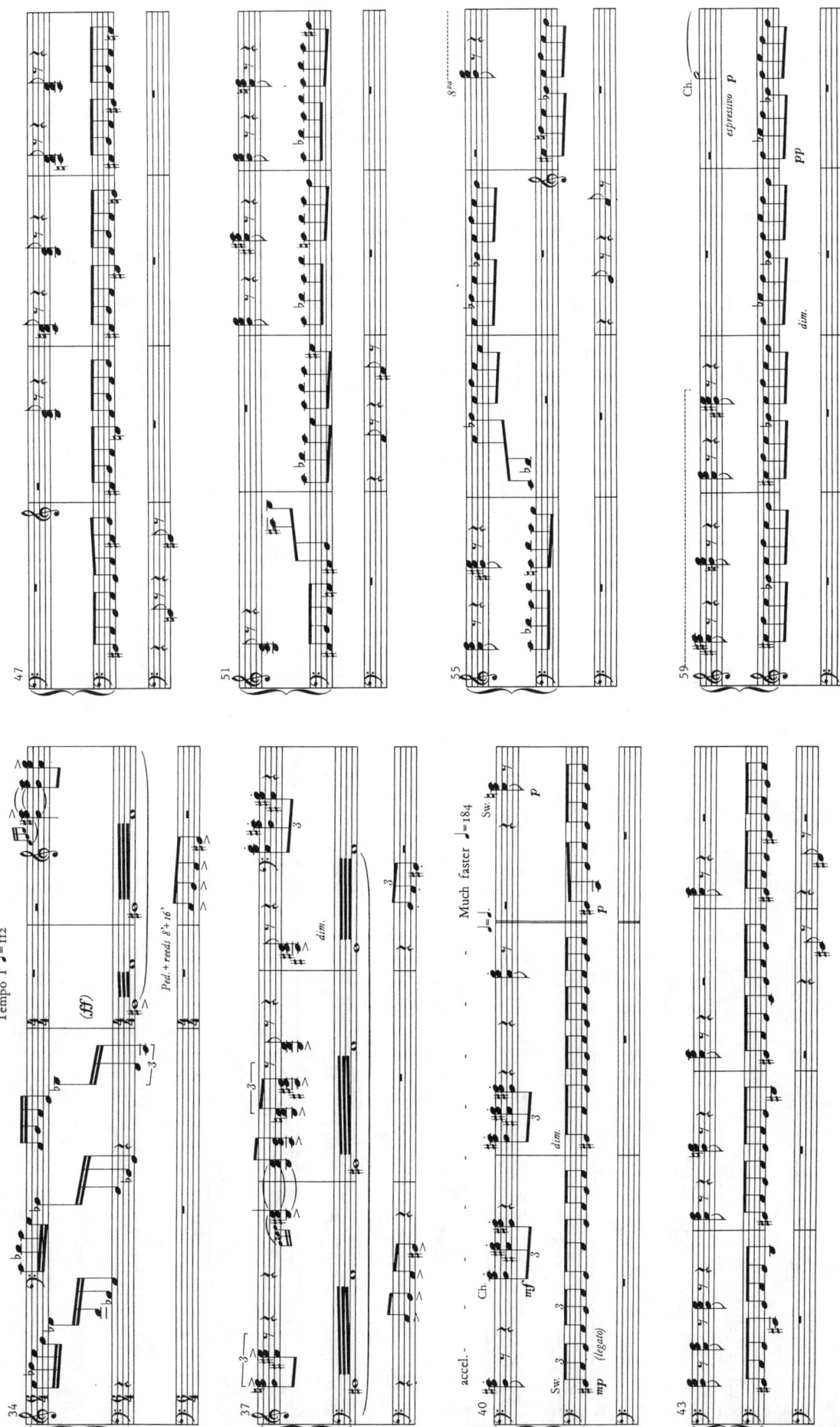

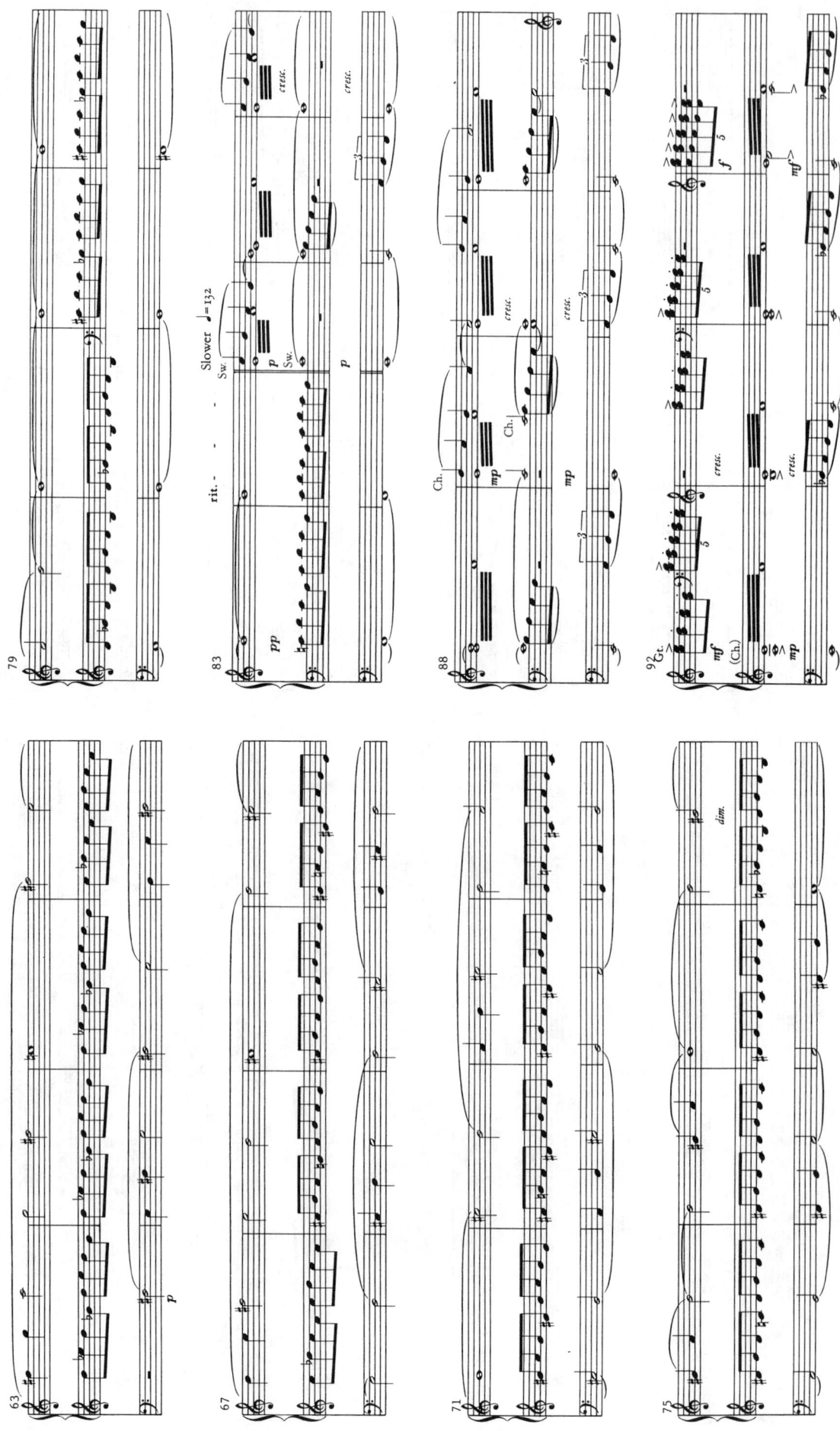

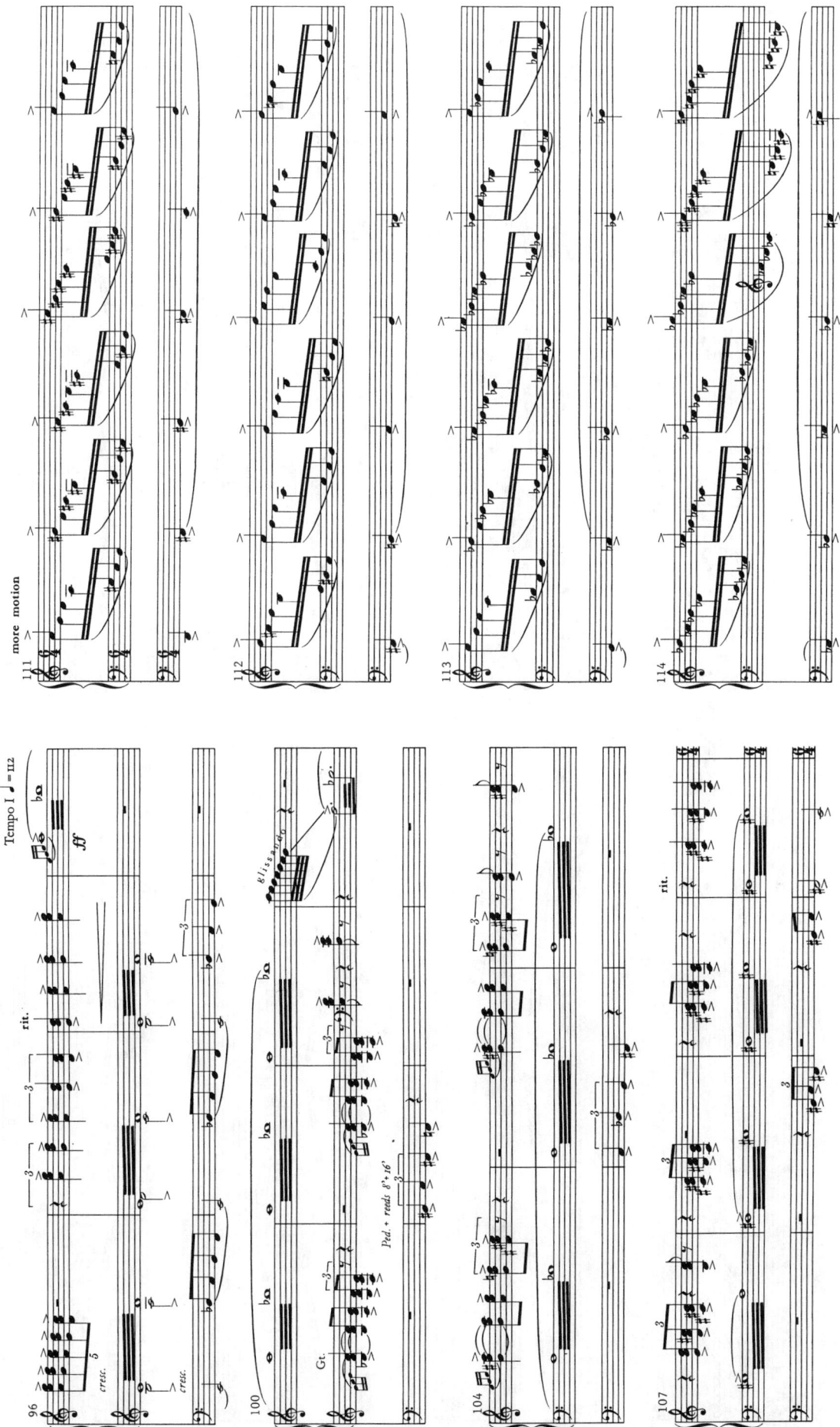

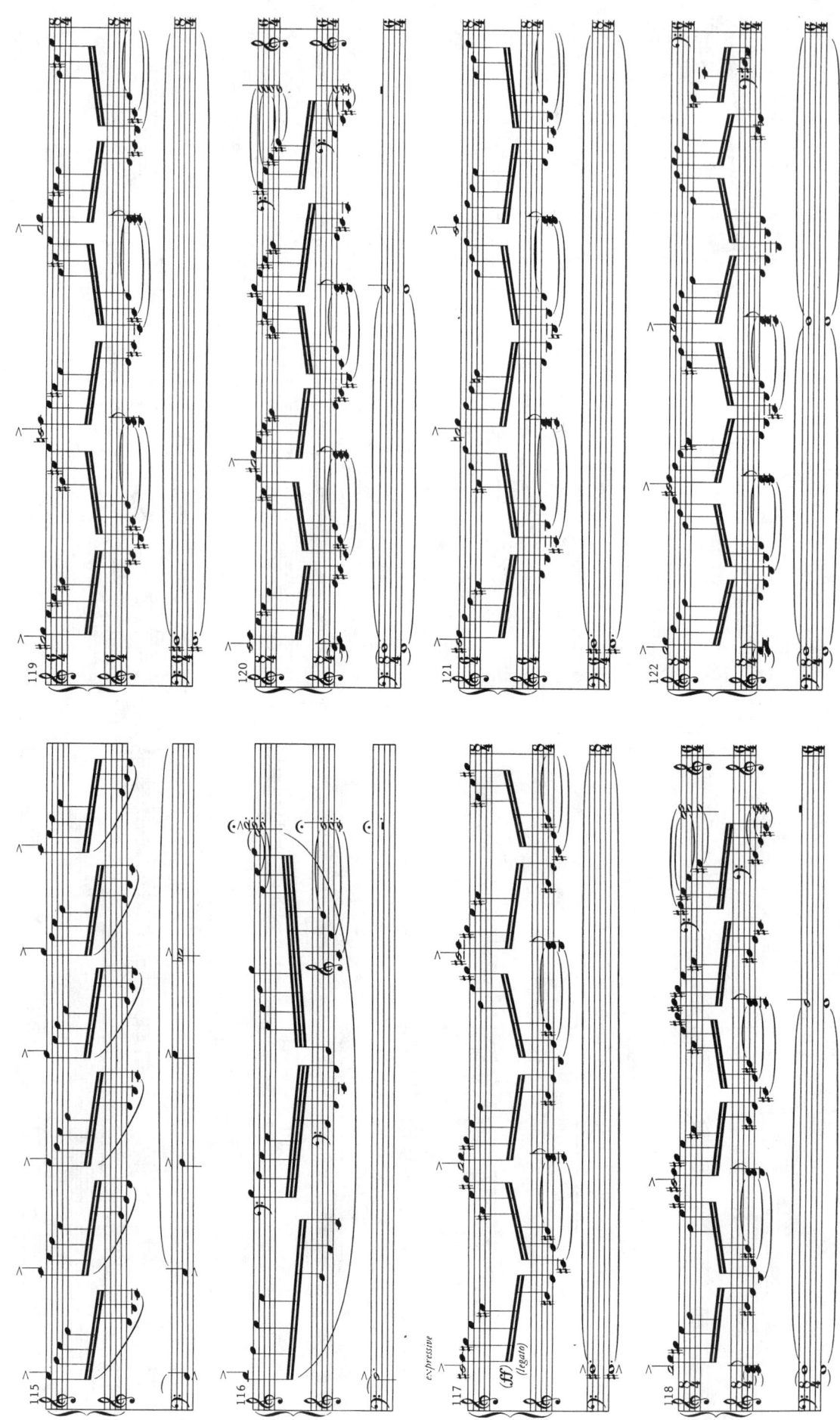

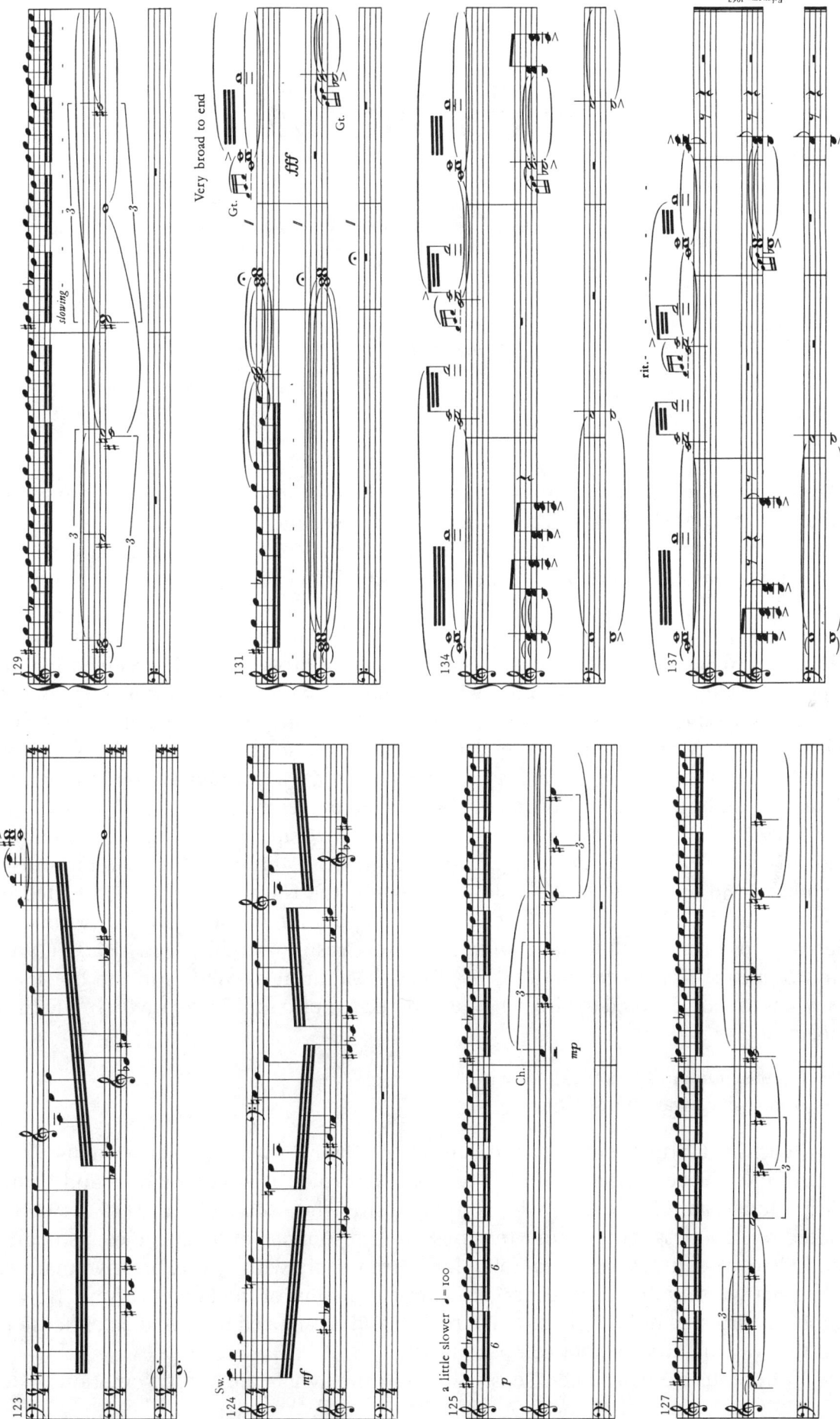

Elena Firsova

(born 1950)

Elena Firsova was born in Leningrad (now St. Petersburg) into a family of physicists. She first attempted composition at the age of twelve, and her formal studies began in 1966 in Moscow at a music institute. From 1970 to 1975 she continued at the Moscow Conservatory, where her teachers were Alexander Pirumov in composition and Yury Kholopov in analysis.

In 1975 she established a crucial contact with Edison Denisov, another leading figure of Soviet and contemporary Russian music. Firsova's music received its premiere outside the Soviet Union in 1979 in Cologne, with performances of the *Sonata for Solo Clarinet* (1976) and *Petrarca's Sonnets,* for voice and ensemble, with texts translated by Osip Mandelstam. In the same season she also received premieres in Paris and Venice. The following year, *Petrarca's Sonnets* was performed in London by Jane Manning and the London Sinfonietta, conducted by Peter Eötvös.

Earthly Life, one of several settings of poetry by Osip Mandelstam, was commissioned by the British Broadcasting Corporation. It was premiered in London in November 1986 by Penelope Walmsley-Clarke and the Nash Ensemble, conducted by Lionel Friend. This work established Firsova's reputation in the United Kingdom and led to two further Mandelstam cantatas for the Nash Ensemble, *Forest Walks* (1987) and *Before the Thunderstorm* (1994). As Gerard McBurney observes in the Boosey & Hawkes catalog devoted to Firsova, one may see a motto for her creativity in the third poem of *Earthly Life*:

Let the moment's lees trickle down—
Don't wipe away the sweet design.

Relishing the moment thus marks much of Firsova's work, which exhibits a persistent melodic bent. In many of her works a solo voice has a central role, and clearly Osip Mandelstam is the poet who counts most for her. Mandelstam (1891–1938) is noted for the classical restraint, terseness, and resonance of language of his poetry, and Firsova's settings are remarkable for harmonizing with that expressive manner. The poet wrote rather little, especially after the advent of the Soviet regime. He was probably arrested in 1937 by the state police, and is reported to have died either in or on the way to a forced labor camp.

In her music Firsova likewise is spare, and she avoids the overtly emotional. Her

intimate and understated idiom thus offers a welcome contrast to the outward drama and programmaticism of late-Soviet music. Elena Firsova's compositions have been featured on Soviet music seasons at the Bath Festival in 1987, the Almeida Festival in 1989, and during the Russian Spring Festival in 1991 at the South Bank Centre. In 1991 she was a featured composer at the Soviet Arts Festival at Butler University, Indianapolis, where *Three Poems by Osip Mandelstam* received its United States premiere by Laurel Goetzinger, soprano, and Anna Briscoe, piano. The setting of the first poem is presented here.

Recent orchestral works include *Augury* (1988), commissioned by the BBC Proms for the BBC Symphony orchestra and chorus conducted by Andrew Davis; and *Cassandra* (1992), written for the BBC National Orchestra of Wales and recorded on BIS Recordings. *Misterioso* (1980), for string quartet, was written in memory of Igor Stravinsky and has been in large part responsible for making Firsova's name known internationally. Recent chamber works include her String Quartets Nos. 5, 6, and 7 written for the Britten, Danish, and Smith Quartets respectively; and *Insomnia* (1993), for four singers on poems by Pushkin, commissioned by WDR and composed for the Hilliard Ensemble. *Before the Thunderstorm*, also on poems by Osip Mandelstam, was composed for soprano and nine players in 1994.

Elena Firsova is married to the composer Dmitri Smirnov; the couple have a son, Philip Firsov, and a daughter, Alissa Firsova. Since taking up residence in the United Kingdom in 1991, Firsova has become increasingly active in the British musical scene and is currently a composer-in-residence jointly with Dmitri Smirnov at Keele University.

Three Poems by Osip Mandelstam (excerpt)

Elena Firsova

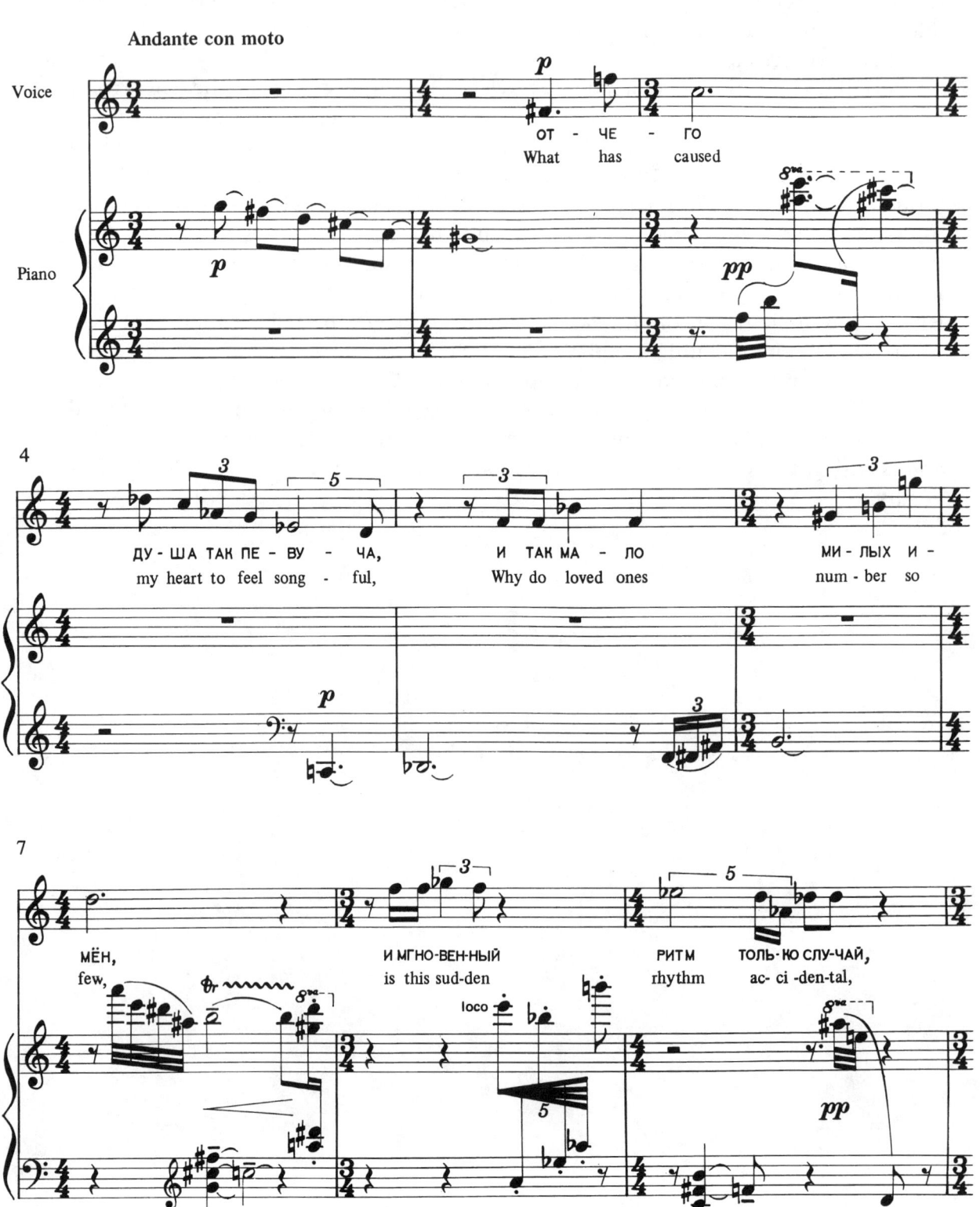

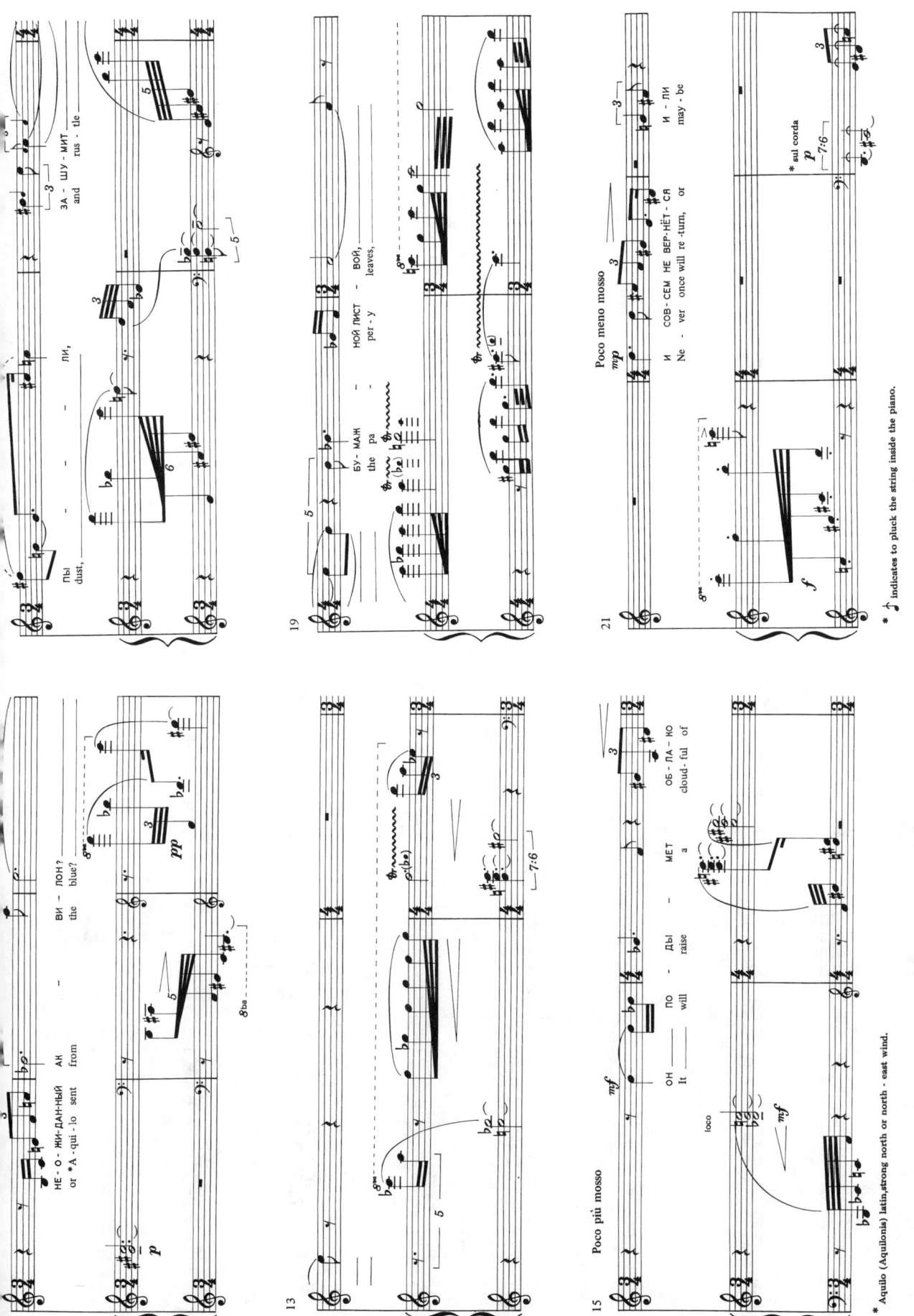

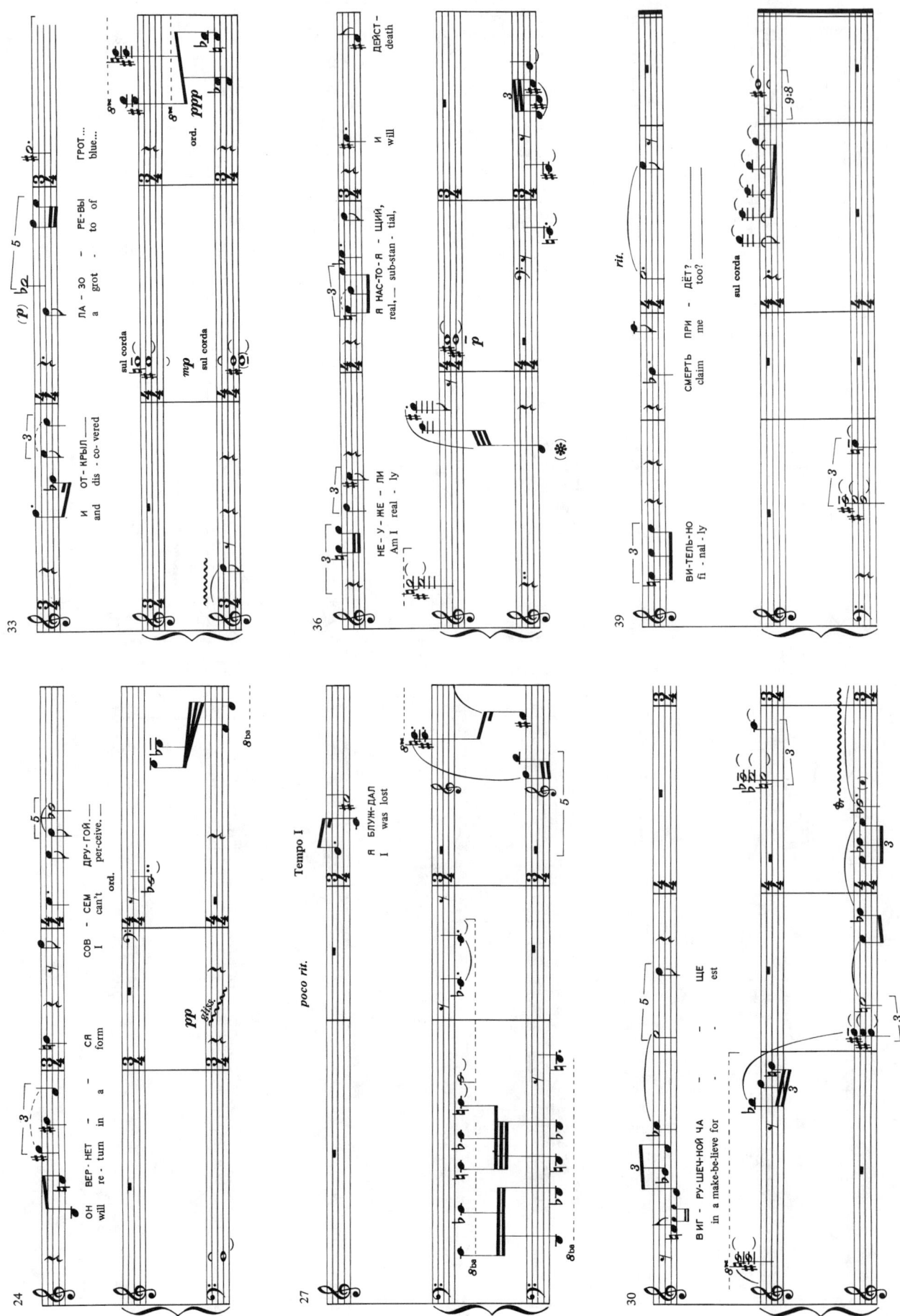

Jennifer Fowler

(born 1939)

Jennifer Fowler was born in Bunbury, Western Australia, and studied at the University of Western Australia. Some of her pieces were performed over the Australian Broadcasting Corporation while she was still a student. She spent the year 1958 on a Dutch government scholarship at the Electronic Music Studio of the University of Utrecht. She has resided in London since 1969. Her husband, Bruce Paterson, an Englishman, is a computer designer; Fowler and Paterson have two sons, Adrian and Martin.

Jennifer Fowler has won a number of international prizes: in 1970 from the Academy of Arts in Berlin, for *Hours of the Day*, for four sopranos and ensemble; in 1971, the Radcliffe Award in Great Britain; and in 1975, first prize in the International Competition for Women Composers in Mannheim, Germany, for *Ravelation*, for string quintet. Her works were performed at the World Music Days in Helsinki in 1978 and in Brussels in 1981, where she was hosted by the International Society of Contemporary Music. Other performances took place at the International Gaudeamus Music Week in Holland, the Asian Composers Festival in Hong Kong, the International Harrogate Festival, the Ring of Fire Festival in London (including a commission by the British Broadcasting Corporation), the Donne in Musica Festival in Rome, and the International Sydney Spring Festival. Fowler is a member of the Fellowship of Australian Composers, the Composers Guild of Great Britain, Sonic Arts Network, the Society for the Promotion of New Music, and the International League of Women Composers, and is a founding member of Women in Music (Great Britain). Much of her music is published by Universal Edition (in London), and she is also represented by the Australian Music Centre ("Sounds Australian"). Her music is available in its entirety through the British Music Information Centre in London.

For the most part, her compositions are written for performing groups that are either unconventional or at times flexible in instrumentation; for instance, her *Piece for an Opera House* (1973) is for two pianos, or one piano with tape, or solo piano. *The Arrows of Saint Sebastian I* (1980) is written for woodwinds, brass, and string quartet; and *Arrows of Saint Sebastian II* (1981), for bass clarinet, cello, and pre-recorded tape. *Echoes from an Antique Land* (1983) is scored for five percussion players, although its 1986 successor, by the same title, calls for a flexible ensemble of five or ten instru-

ments. *We Call to You, Brother* (1988) is written for an ensemble of flute, English horn, cello, percussion, two trombones, and didjeridoo. *Voice of the Shades* (1977) is set for soprano, oboe or clarinet, and violin or flute, although Fowler says that it may also be performed by "two trumpets and oboe (or clarinet) or clarinet, oboe, and violin (or flute)."

Jennifer Fowler begins an unpublished article, "My Own Ears," by quoting the ancient Greek poet Sappho: "All that I heard was my own ears drum." She argues for new sound creation based in part on the past:

> Why always seek the new? We have to do battle against the inertia of the human mind, which is biased toward traveling along unknown paths in known directions. . . . One's own expectations [as a composer]—like everybody else's—are formed from the known. Somehow one has to trick the imagination into making a step, seeing a vision outside itself; one has to communicate the excitement, have something to say. Of course, playing with new sounds does not necessarily mean that a composer has something new to say! But it is one way of stimulating the imagination in a new direction. . . .

Perhaps substantiating her tendency to write with variety and flexibility of scorings, Fowler writes in the same article:

> Unusual combinations in combination: I doubt that I will stay in unison for long! There will be the attraction of "fraying" the sound, having it not quite unanimous, not quite in focus. There is the possibility of different waves or phases, of varying the amount of difference, of coming together again for rest points. Greater or lesser unanimity; phrasing made of greater or lesser activity; rhythm made of greater or lesser clusters of notes; pulses advancing and retreating: these are recurring ideas.

About her process of composing, she observes:

> The first page: everything is implied in it, and it is difficult to get it right. Lately I have taken to re-writing that first page so many times! I am attracted to the idea of "construction": subduing the "material" in order to manipulate sound objects, imposing order in a kinetic-visual way. "Structure" becomes "sculpture," but with the added fascinating ingredient of time. Then there is the organic, "start-with-a-seed-and-grow" approach. I can see why I distrust that. It makes it too easy to fall into a received sound world. In the event, one balances both approaches in tandem. So, in the beginning there is an idea, a plan—partly map, partly seed. It has to be flexible enough to allow things to happen. As one makes progress into the piece, so one constantly returns to the beginning to allow that first page to carry the right implications. Through writing the piece one modifies the original plan, so for a long time there is constant interaction between the plan-in-advance and the piece as it actually emerges. . . .

Jennifer Fowler touches on a condition seen throughout the history of women composers and continuing today, that of resources and possibilities that must conform to the parameters of a married life.

> Since 1968 [her year in Utrecht] I haven't had a chance to work with electronic equipment . . . the studios are still all in institutions and the thing I have lacked since 1969 is a connection with an institution. . . . There are plans in Britain to give composers access to University electronic studios during vacations. There is such a scheme in operation in Newcastle. Let's hope that the idea is taken up and extended. One of these days, an opportunity [for electronic composition] might come up for me. It will have to be close enough to where I live, so that I can continue to be wife and mother.

In the meantime, I suppose that what I do is envisage what isn't possible and then translate it into what is possible.... Supposing I had ... eight horns, fifteen double basses, and the Albert Hall organ ... a couple of synthesizers and two banjos? The imaginative juices start flowing. Then it is sometimes possible to *translate*.... It doesn't always work, but the piece you write is likely to be better than if you started out with only limitations in mind.

She speaks for many women composers especially, but also for men, when she observes, "Limits can also be a powerful stimulant, the ingenuity needed to overcome limitations can suggest other ideas that might not have occurred otherwise: detailed working needs a detailed territory."

Fowler offers the following performance notes and general analysis for *Blow Flute: Answer Echoes in Antique Lands Dying*, for solo flute. One may also request a complete analysis of the composition from her at 21 Deodar Road, London SW15 2NP, United Kingdom.

It is permissible to shorten the title of this piece to "Blow Flute" for practical purposes!, but the rest of the title does have a function too. It can call up the poetic echoes of Tennyson's:

Blow, bugle, blow, set the wild echoes flying,
Blow bugle: answer, echoes, dying, dying, dying.

It can call up musical echoes, too, at the cadence points: echoes of formal cadences from antique times.

Otherwise, the line is fluid; gathering around a nodal point, and dividing off to other nodal points. The rhythm progresses in groups of even notes: groups of 2s, 3s, 4s, 5s, accumulating and retreating. There are knots of accumulations and tensions, sometimes dispersed, sometimes gathered together to form a cadence.

The piece is about the sound of a flute, a sound calling up eddies and currents, and echoes.

Blow Flute: Answer Echoes in Antique Lands Dying was written in 1983.... A suggestion for multi-media performance is to play the piece in conjunction with a video of the Aurora Borealis (Northern Lights), which shows currents of changing lights in the northern sky. The video has its own sound track, which should be turned down. The video is available from the Geophysical Institute, University of Alaska, Fairbanks, Alaska 99775–0800, USA.

Bibliography

Fowler, Jennifer. *Biography*. New Music Articles No. 4. NMA Publications, Box 185, Brunswick, Australia 3056.

Discography

Blow, Flute on *The Flute Ascendant*. Laura Chislet, flutist. Vox Australis, Australian Music Centre, 1992, CD. In Australia: Vox Australis, Australian Music Centre, P.O. Box N690, Grosvenor Place, Sydney; in the United States: Albany Music Distribution, 98 Wolf Road, Albany, NY 12205–0011.

Blow Flute: Answer Echoes in Antique Lands Dying

Jennifer Fowler

23

Sofia Gubaidulina

(born 1931)

Sofia Gubaidulina was born in Chistopol, Tatar Republic. She graduated in 1954 from the Kazan Conservatory in piano and composition. She continued in composition at the Moscow Conservatory, working with Nikolai Peiko, a pupil of Dmitri Shostakovich; and pursued postgraduate study with Vissarion Shebalin. From 1963 to the 1980s, she lived in Moscow, working as a free-lance composer. She now resides in Germany. With Schnittke, Denisov, Firsova, Silvestrov, and Kancheli, Gubaidulina is acknowledged as a leader in Soviet music and, in recent years, of music from nations of the former Soviet Union.

In many ways Sofia Gubaidulina exhibits national Russian influences, although her Tatar background plays a certain role. In 1975 she and the composers Vyacheslav Artyomow and Vikto Suslin founded the group Astreya. They explored the music of historic folk instruments from Russia, the Caucasus, and Central Asia, improvising on them and eventually incorporating them into compositions. For Gubaidulina, this investigation resulted in three collections for domra and piano, entitled *On Tatar Folk Themes*, and *De Profundis* for solo bayan.

Her explorations in new sound and new insights into musical time have also resulted in the recasting of Western traditional scoring, such as her Concerto (1976), for symphony orchestra and jazz band; and *Garden of Joys and Sorrows* (1980), for flute, viola, harp, and speaker, presented below. In many of her works one hears a notable timbral enlargement, thanks to her use of percussion. *Offertorium*, for instance, is a violin concerto that has seen three versions, the last in 1986; the score calls for five bongos, crotales, guiro, and marimba together with a more standard battery. Gubaidulina has also attended to the pragmatic considerations of music for children: *Counting Rhymes* (1973) consists of five children's songs, and *Musical Toys* (1969) is a collection of piano pieces for children. Her large catalog contains many works for traditional scorings, too, such as piano solos, works for solo wind or brass instruments and piano, and vocal and choral works.

Sofia Gubaidulina's oeuvre is notable because it contains very little absolute music. She nearly always finds expression beyond the strictly musical, choosing instead to reveal something of the philosophical or mystical, the instrumental "action" or overt drama through music. Christian symbolism figures consistently in her music,

and did so even before the recent return to such expression arose in the former Soviet Union.

Her literary interests range widely. She has set ancient Egyptian poetry in translations by Anna Akhmatova (*Night in Memphis*, 1968), and Persian poetry of Omar Kayyam, Hafiz, and Khakani (*Rubayat*, 1969). Her large-scale vocal works include settings of the German poetry of Francisco Tanzer (*Perception*, with excerpts also from the Psalms, and *Garden of Joys and Sorrows*, 1980), and of texts by the Anglo-American poet T.S. Eliot (*Homage to Eliot*, 1987). She has set poems by the contemporary Russian poet Marina Tsvetayeva in *Hour of the Soul* (1974) and *Hommage* (1984).

Sofia Gubaidulina's music is characterized by an unfailing devotion to ideals for humanity and faith in God. Her music also has been influenced, unconsciously, by Oriental spirituality. Gubaidulina is not a nationalist or a sentimental musician of the late-Romantic variety; instead, her consummate mastery of compositional technique allows her to choose and synthesize the European past and present, and the American avant-garde, for her own purposes. Reluctant to write or speak about her music, she nonetheless has expressed in few words a powerful credo, provided in the composer catalog prepared by Musikverlag Hans Sikorski, her principal publisher:

> To my mind the ideal relationship to tradition and to new compositional techniques is the one in which the artist has mastered both the old and the new, though in a way which makes it seem that he takes note of neither the one nor the other. There are composers who construct their works very consciously; I am one of those who "cultivate" them. And for this reason everything I have assimilated forms as it were the roots of a tree, and the work that grows out of its branches and leaves. One can indeed describe them as being new, but they are leaves nonetheless, and seen in this way they are always traditional or old.
>
> Dmitri Shostakovich and Anton Webern have had the greatest influence on my work. Although my music bears no apparent traces of it, these two composers taught me the most important lesson of all: to be myself.

The composer also provided the following program note, translated here by Laurel Fay:

> The *Garden of Joys and Sorrows* (1980) is a one-movement piece for harp, flute, and viola. It was conceived under the strong influence of two directly contradictory literary phenomena: 1) the work "Sayat-Nova" by Iv Oganov of Moscow, about the famous Eastern storyteller and singer, and 2) verses by the twentieth-century German poet Francisco Tanzer. Vivid Eastern color was counterposed with a typically Western consciousness. But both of these works had significant inner similarities: their contemplativeness and refinement.
>
> Such phrases in Iv Oganov—"the ideal of a flower's pain . . . , the peal of a singing garden grew . . . the revelation of the rose . . . the lotus was set aflame by music . . . the white garden began to ring again with diamond borders . . . "—these impelled me to a concrete aural perception of this garden. And, on the other hand, all this ecstatic flowering of the garden was expressed naturally in the sum reflections of F. Tanzer about the world and its wholeness.
>
> At the basis of the musical rendering of the form of this piece is the opposition of the bright, major coloration of the sphere of natural harmonics against the expression of the intervals of minor second and minor third.

The piece ends with a spoken recitative with these lines from the diary of Francisco Tanzer:

> When is it really over? What is the true ending?
> All borders are like a line drawn with a stick of
> wood or the heel of a shoe in the sand.
> Up to here . . . , there's the borderline. All this is
> artificial.
> Tomorrow we play another game.

Bibliography

"Sofia Gubaidulina." Publisher's catalog and biography. Hamburg: Musikverlag Hans Sikorski, 1988.

Garten von Freuden und Traurigkeiten

Text by Francisco Tanzer

Sofia Gubaidulina

*) langes Glissando mit dem Schlüssel / long glissando with the tuning key

© 1981. Reprinted with the kind permission of Musikverlag Hans Sikorski, Hamburg.

29

31

*) Papier zwischen den Saiten / paper between the strings

34

*) die vibrierenden Saiten leicht mit dem Schlüssel berühren / touch the vibrating strings gently with the tuning key

35

36

38

*) dieser Schlüssel markiert den Gesamtumfang des Instrumentes / this clef indicates the total compass of the instrument

40

Barbara Heller

(born 1936)

Barbara Heller was born in Ludwigshafen am Rhein. At the Musikhochschule in Mannheim she studied piano with Helmut Vogel and composition with Hans Vogt. From 1958 to 1962 she remained there to teach piano, at the same time beginning a career as a free-lance composer and pianist for the dancer Roger George. In 1962–63 she studied composition with Harald Genzmer in Munich, and since 1963 she has been occupied independently in composition and piano, basing her career in Darmstadt. One element of her composition has been film music, which she studied with A.F. Lavagnino at the Accademia Chigiana in Siena.

Since 1978 Barbara Heller has devoted considerable attention to the music of women composers. She played an important role in establishing the Internationalen Frau und Musik [International Study Group on Women and Music]. She has prepared numerous scores of earlier composers for publication, in particular, piano music by Fanny Mendelssohn Hensel. From 1986 to 1992 she was on the board of the Institut für Neue Musik und Musikerziehung [Institute for New Music and Music Education] in Darmstadt.

Her music centers on the piano, but it also includes chamber music, such as the composition presented here, *Tagebuch für Violine und Klavier, Teil II*. Since the mid-1980s, Heller has collaborated with female visual artists, and she has experimented with improvisation, electronic sounds, and sounds from the environment. She is active as a recitalist and as a consultant for several broadcasting companies.

In a direct communication, Barbara Heller writes concerning the *Tagebuchblätter* (an alternative title for the piece below):

> I composed the work during a period when I had two duos, the Darmstädter Duo, with the violinist Konstantin Gockel, and the Tailleferre Duo, with Helga Wähdel. That means that I enjoyed much practice time and my ears were full of violin-plus-piano sounds. I loved it. Movement 1 employs the system of writing a short melody and repeating those notes in the harmony, in the piano part. In Movement 2, a simple chord in the piano is used as a basis, with a simple melody in the top. In between is the "imprisoned melody," going back and forth. The German expression "hin und her" also means "restless, looking here and there to get out of prison." The tones in

the violin are those of the twelve tones not found in the piano. While playing it we named this piece "Tiger in prison."

Movement 3 was written as a birthday greeting for Christa Weschke on her fortieth birthday. It uses the rhythm "Chris-ta Wesch-ke hat Ge-burts-tag."

The illustration on the cover of this anthology, entitled *Rotation*, is one of a series of Heller's graphic scores:

> This series of *Kartenspiele* [card plays, as they take the form of a postcard] relates to my encouragement of improvisation. I thought about melodies ascending and descending. What happens? When a melody is going up or down, are there emotions? I observed that all my early compositions ascended! And nowadays I like "down mutations." The graphics are a search for another way to make music between real structure and improvisation, to bring more freedom to "live music."

Tagebuch für Violine und Klavier,
Teil II: Die Linien

Barbara Heller

46

II

Adriana Hölszky

(born 1953)

Adriana Hölszky was born into an ethnic German family in Bucharest, Romania. In 1971, she moved to Stuttgart, where she has preserved her "foreignness" in certain ways. Her composition studies with Stefan Niculescu at the the Bucharest Conservatory suggested a manipulation of both traditional academicism and socialist realism, with its customary emphasis on pseudofolklore. Hölszky has taught music theory and aural training at Stuttgart since 1980. According to the essay by Gerhard R. Koch, in the Breitkopf & Härtel catalogue on Hölszky, she places little importance on her role as woman composer, first of all, because there is a long and distinguished history of women composers in Eastern Europe. In addition, according to Koch, Adriana Hölszky refuses to be limited to a "female aesthetic," to be treated with indulgence and condescension, or to submit to the fashionable obligations of

> an officious avant-garde . . . which decrees how one should not compose—not like Darmstadt. . . . She will not submit to systems foreign to her, nor will she escape into the vast expanses of postmodernism, of an arbitrary anything goes—which is potentially still more dangerous.
>
> Chaos under control—these words perhaps best outline Adriana Hölszky's aesthetic credo. . . . The impression of extreme, even improvisatory flexibility, of exceptional and unrestricted mobility . . . as well as a meticulous notational practice, leaving next to nothing to liberal approximation.

Hölszky nonetheless acknowledges contributions from tradition to her development, particularly the complex folkloric tradition of Romania: heterophony and its simultaneity of similar lines, and microtonal dissolution and embellishment. She likes musical puzzles, perhaps influenced by her family of scientists; and as a pianist she is especially aware of the repertoire and the primordial nature of the piano. In 1988, under the direction of Hans Werner Henze, the Munich Biennale of New Theater Works premiered her *Bremer Freiheit* (1987), perhaps her most impressive work to date. It is based on a text by Rainer Werner Fassbinder. Gerhard Koch describes the piece as turning the multiple murder "into nothing less than an angelic heroine by a radical inversion of (almost) values. The composer is meticulously aiming to perfect

the nightmarishness of a horror whose excess is not devoid of the comic." In effect, the piece is an homage to a woman who frees herself from family ties through murders by poison.

The double string quartet *Hängebrücken* [Suspension Bridges] was composed in 1989–90 and premiered by the Nomos and Pellegrini quartets at the Wittener Days for New Chamber Music in 1991. The program offered an "encoded attachment" articulated by the composer but apparently paraphrased:

> Here we do not have an appropriation, as in many an "arrangement," but a compositional expression of futility, the impossibility of approach to the unattainable and untouchable, music in danger of collapse, dizzying, on swaying ground, suspension bridges over eeriness. "It is as if the citations would swim in dirty water." Distorted, broken, inverted: fragments from Schubert's string quartets are heard from afar as phantoms of reminiscence between the eruptive sounds of the string instruments and their aggressive drive into the realm of noise. All the dust is scratched away as well as whirled up, and nothing comes to light under the dust. It is thus that Schubert's music is perhaps rendered more strongly present to the imagination of the searching and straining audience than it would be if conjured up in the "musical flesh."

Hängebrücken I is the upper part of the score, *Hängebrücken II* the lower; when combined they form the composition *Hängebrücken III*. The two quartets may be played separately or simultaneously. According to the prefatory notes in the score, the underlying concept of this piece is that horizontal, "endless" Schubertian time can be vertically transformed. In this way, the structure is enhanced with a great concentration of structural fields which emit a "pulsating" or "vibrating" sound energy. This surface play of fields, which are discontinuous and sharply distinct, should be expressed with a maximum differentiation and relevancy when performing the work. The "Schubert" fields (indicated in German as *an Schubert*) occur in the first movement. They are modified or distorted fields of quotations drawn from the Quartet in D minor, D 810. The first six pages of this work are presented here.

Discography

Hängebrücken I und II. Nomos Quartett, Pelegrini Quartet CPO 999 112–2/WDR. Released 1993. CPO; Lübecker Str. 9; D–49124 Georgsmarienhütte, Germany.

Hängebrücken I: Streichquartett an Schubert (excerpt)

Adriana Hölszky

Hängebrücken II: Streichquartett an Schubert (excerpt)

Adriana Hölszky

© 1991 by Breitkopf & Härtel, Wiesbaden. Reprinted by permission.

N.B.¹: alle pont. oder tasto - Angaben moltissimo ausführen.
N.B.²: das tremolo so dicht wie möglich ausführen.

N.B.¹: das tremolo so dicht wie möglich ausführen.

N.B.²: alle pont. oder tasto - Angaben moltissimo ausführen.

53

NB: die prägnanten Figuren sollen sich bei jedem
Streicher individualisieren und vom Klangfeld abheben.

NB¹: die prägnanten Figuren sollen sich bei jedem
Streicher individualisieren und vom Klangfeld abheben.

N.B².: Die Wischbewegungen wie ein Scheibenwischer ausführen.

54

NB¹: das tremolo immer so dicht wie möglich ausführen.
NB²: weites gliss. mit unbestimmtem Endpunkt.
NB³: ♩=96 bedeutet hier die höchste Geschwindigkeit.
NB⁴: die leisen dynamischen Werte sehr differenziert und bis an der Grenze der Hörbarkeit ausführen.

NB¹: ♩=96 bedeutet hier die höchste Geschwindigkeit.
NB²: weites gliss. mit unbestimmtem Endpunkt.
NB³: die leisen dynamischen Werte sehr differenziert und bis an der Grenze der Hörbarkeit ausführen.

NB: das tremolo so dicht wie möglich ausführen.

N.B.: das tremolo so dicht wie möglich ausführen.

Accidentals apply only to the note before which they are placed.

arco or pizz. as high as possible

muffled pitch, percussive sound. The left hand damps the vibration of the strings.

Bow with maximum pressure (scraping noise); however, use only a little bow in order to produce a delicate noise (almost like a door creaking in the distance).

The left hand covers the indicated open strings so that only a creaking noise is heard – and not the open strings – when the bow is drawn with excessive pressure.

Like windshield wipers:
Draw the bow back and forth between the fingers of the left hand and the bridge. The back-and-forth "sweeping" motion along the string with the hair of the bow (slightly diagonal bow movement) yields a soft noise, whereby the notated pitches are of secondary importance.

w sweeping motion on the strings as described above

The same action, but this time the left hand glides along the strings on natural harmonics.

Do not bow, but only "sweep" along the strings at the beginning. Grating sound at the end of the bow glissando (bow here as well).

Combination of the following actions: grating, subito normal, subito sweeping of the string.

Bow on the body of the instrument; the given string (here the E string of the violin) should also be included in

The dynamic values in the circles apply to the entire quartet, contrary to those that are not within circles, which apply only to one instrument at a time.

The indications (fermatas, mutes) notated above the barline or double barline apply to all performers.

above the line: percussive action (as indicated) on the fingerboard (try as much as possible to hit two strings at the same time), whereby the left and should prevent the vibration of the open strings.

on the line: percussive action (as indicated) on the bridge (with damped strings)

under the line: percussive action (as indicated) behind the bridge (try as much as possible to hit two strings at the same time), also with damped strings

L. H. left hand

R. H. right hand

F hit with the fingertip

Tap the top of the instrument or another part of the instrument's body with the fingertips (use the indicated fingers of the left or right hand as much as possible) as fast as possible (like a on a keyboard).

as fast as possible

as fast as possible in accelerando

as fast as possible in rallentando

series of notes almost glissando through all the registers, as fast as possible (the diagonal line refers to the "as fast as possible")

figure in accelerando

figure in rallentando

very irregular sequence

mute on or off

bridge or fingerboard; refers only to the note below the arrow

transition from "ordinario" to "tasto" or from "tasto" to "ordinario"

short ⟷ long Fermatas of different length

	the bowing with excessive pressure at the end.	*pizz h.d.S.*	pizz. behind the bridge (on the given string)
	gettato on the body of the instrument	pizz. Wk	pizz. on the peg box (with the left hand)
	Bow with the hair of the bow on the tailpiece.	*pizz FN*	fingernail pizzicato of the indicated muted string (drive the glissando as far as possible)
c. l. b.	con legno battuto, strike the string(s) with the wood of the bow		
	Hit the given strings with the wood of the bow; the left hand damps the strings so that only a percussive sound – and not the open strings – is heard.	*c.l.b. pizz*	At the glissandi, the starting note should be left quickly so that the entire duration of the note value is executed in glissando.
	Glissando along the strings starting as high as possible (with the left hand). The right hand – with the bow in the fist – strikes irregularly with the bow, as fast as possible (almost like a Morse code) while doing a glissando at the same time; this should yield a delicate water-drop sound. All four strings should be muted with the flat of the left hand so that no pitches can be distinguished.		Bartók pizzicato with definite pitch
			Bartók pizzicato muted on the given string. One only hears the slapping of the string against the fingerboard.
			Pizz. (here arpeggiato) muted as high as possible. The four strings are damped with the left hand so that only a percussive noise is heard.
			In the cello: pull at the string with the left hand and touch it with the wood of the bow very lightly immediately thereafter, so that a loud rattling sound is produced.
a. b. or arco batt.	Strike the string(s) with the hairs of the bow.		
l. + c. batt.	legno + crini battuto: strike the string(s) with the wood and hairs of the bow at the same time.	m. v.	molto vibrato
			irregular circular motions of the bow along the string
l. + c. gett.	legno + crini gettato		Proceed seamlessly from a slow, broad vibrato to a rapid and dense vibrato and vice versa.
arco gett.	arco gettato: let the bow spring		
arco salt.	arco saltato, bouncing bow (with the hairs)		a very broad vibrato, almost like a glissando
c. l. salt.	con legno saltato, bouncing bow (with the wood)		a short, rapid glissando
	bouncing bow with bow glissando on the muted strings E and A		a very irregular glissando
			quarter-tone higher, or quarter tone lower
legno tratto	Bow with the wood of the bow.		gentle or abrupt quarter-tone shifts
punta d'arco	Bow with the tip of the bow.		Repeat the same event.
h. d. S. a. d. S.	behind resp. on the bridge		The figure enclosed within the square is to be repeated over and over again until the end of the duration indicated by the dotted line.
	Bow with the hairs of the bow behind resp. on the bridge.		

Betsy Jolas

(born 1926)

Betsy Jolas identifies herself as "coming from French culture but with an Anglo-Saxon element that only enriches." She was born in Paris but spent the years 1940–46 in the United States. Her father, Eugène Jolas, was a journalist and poet who had been born in the United States. Her mother, Maria MacDonald, a native of Kentucky, gave up a career as a singer to become a translator. In 1937 the composer's parents founded a literary revue, *Transition*, which they edited throughout its lifetime, until 1947. With her parents having introduced landmarks of contemporary English-language literature into France, such as James Joyce's *Finnegans Wake,* Jolas counts the literary influences of her youth as greater than the musical ones.

After leaving France with her family at age fourteen, Jolas pursued "fragmentary but original" instruction in music composition in the United States. Dalcroze eurhythmics figured in her American experiences, as did the singing of the Dessoff Choir, directed by Paul Boepple. Jolas recalls her early encounter with the music of Roland de Lassus, Josquin des Près, and Giovanni Battista da Palestrina as "a turning point in my life, when I became a contrapuntist rather than harmonist—I do not care for what is square and predictable." Betsy Jolas received a Bachelor of Arts in 1946 from Bennington College, where she studied theory with Paul Boepple, organ with Carl Weinrich, and piano with Helen Schnabel.

Returning to France, Jolas decided to enter music composition as a career, but she quickly became aware of her lack of technical mastery. After coaching with Arthur Honegger, she found herself torn between the camp of the anti-serialists, such as Darius Milhaud, and the allure of serialism: "Webern's *Five Pieces* Opus 10 were a lightening bolt, very quiet but containing all the passion of the term." And yet, ambivalence remained toward serialism: "I was always too lazy to count the rows." *Plupart du temps II* nonetheless gives evidence of a disposition learned early from the post-Webernists about brevity, simplicity, and timbral play. She similarly was moved by the dodecaphonists' "spirit of community, so rarely seen in Western music."

As a young French composer, Betsy Jolas was awarded the indispensable prizes from the Paris Conservatory—for fugue in 1953, for analysis in 1964, and for composition in 1955—and set off on the path to her important, international career as composer. While she does not dwell on obstacles she faced as a woman in composition, she quietly alludes to them in her writings. It was not until 1965 that she received a concert performance of importance, in her view, when Pierre Boulez organized one,

at the Domaine Musical, for her string trio with soprano, *Quatuor II*. As she understood the situation, it was at the concerts of the Domaine Musical that "things in Paris happened, that one heard the compositions that counted." A full appreciation of her composition evolved alongside respect for her teaching. She was assistant to Olivier Messiaen at the Conservatory from 1971 to 1974 and succeeded him as Professor of Analysis in 1975 and as Professor of Composition in 1978. For a while during the same period, she occupied the Chair of her former teacher Darius Milhaud, when she was Visiting Professor at Mills College in California.

The nature of the human voice has always occupied Betsy Jolas. Her mother sang, and she recalls "a monotonous English song, the monotony of which disappeared miraculously with the changes of color on the same notes." She had a childhood fascination with the "Bell Song" from Delibes's *Lakmé*, which she heard on the phonograph—"the voice as an instrument, detached from its daily chores, from its attachment with the world." Likewise the role of Boris Godunov, as sung by Chaliapin, and the vocality of Debussy's *Pelléas et Mélisande* became fixed in her mind. The latter showed "a prosody that seems to fall back upon the beat, although cast in simple schemes of triplet eighths." Parallel to this was her discovery of the Renaissance composer Roland de Lassus and the expressive recitative of the early Baroque. In the music of Betsy Jolas, therefore, vocality is fundamental. It is a direct presence, involving a precise inflection and a penchant for counterpoint. Often the distinctions are blurred between vocal and instrumental works, as in *Quatuor II*, for voice and string trio, or in the voiceless *D'un opéra de voyage*, where "the instruments are made to do what the voice does in daily life, but whereby the instruments are stylized, laughing, weeping, calling out." An analogous combination of voice with instruments, in which the expression is pronounced in the form of a dialogue, occupies Jolas in the score below, *Plupart du temps II*.

Critics have frequently remarked that the music of Betsy Jolas has entered the 1990s with an increased vigor and freshness. When the Quatuor Arpeggione premiered her *Quatuor V* in February 1995 at the Opéra Bastille in Paris, Anne Rey wrote in *Le Monde*:

> Perhaps never in recent years has one sensed such a fertile terrain for musical creation, situated between the quietness of postmodernism and a post-serial modernity that is resolutely aggressive. . . . Betsy Jolas constantly sees her way clear and breaks out when she senses that, in her writing, comfort is settling in.

Jolas has responded insightfully to questions about women as composers:

> On the one hand I think that there is a feminine sensibility (which is not what one would believe—sweetness, elegance, poetry, refinement. . .). On the other I refuse absolutely to confirm, "now there, that's music from a woman." In my view the less one pins down our sensibility, the better that would be. As for having more than a man the need for a violent temperament to assert herself, it is possible but not certain. Doubtless one would need to find a feminine form of violence. . . . The essential problem is not so much the intermixing of unfavorable forces but reticence, even refusal by women to transform fundamentally the image that one has had of them for centuries. My experience has always shown that men insist on being convinced.

Plupart du temps II is a "pièce de concours," written for qualifying juries in saxophone at the Paris Conservatoire in 1989. In a personal communication, the composer recalls the genesis of the work:

From 1949 to 1989, forty years separate *Plupart du temps I* for mezzo soprano and piano, six songs on poems of Pierre Reverdy, from *Plupart du temps II*. The latter was composed on one of these poems set earlier, augmented by fragments taken from the same poem collection, for tenor voice, tenor saxophone, and violoncello. *Plupart du temps I*, still unpublished but often performed, had been the reflection of an unforgettable artistic encounter between the great, aging poet and the young, restless, and intense musician who I was in those days. Forty years later, upon re-reading the same poem "En face," and reconsidering the music that I had provided for it long since, I brought to mind that remark so true made by Schoenberg: "when I was young, I had set poems to music that I did not understand. But my music—it understood them. . . ."

The text, a fantasy and evocation by Pierre Reverdy, may be translated as follows:

Through the window
The news enters...
On each slate that slipped from the roof
Someone had written a poem...
The gutter is trimmed with diamonds
At the edge of the roof,
At the edge of the roof a cloud dances...
Three drops of water hang from the gutter,
Three stars of diamonds, three drops of water, Oh...
And your eyes, and your brilliant eyes that
Look to the sun through the pane...
Noon...
On the roof there is no longer any light
Only the sun and the signs your fingers make...
Signs your hand made behind a curtain...

Betsy Jolas

© 1990. Reproduced by permission of Editions Alphonse Leduc & Cie. All rights reserved.

64

65

Barbara Kolb

(born 1939)

Barbara Kolb completed her undergraduate studies in clarinet and composition at the Hartt School of Music of the University of Hartford in Connecticut. After graduation she continued studying there with Arnold Franchetti, while serving as clarinet and music theory instructor and performing as E-flat clarinetist in the Hartford Symphony. In 1964 Kolb pursued composition studies with Lukas Foss and Gunther Schuler at Tanglewood, and the next year she received a master's degree from the Hartt School.

After studying in Vienna on a Fulbright Scholarship in 1966, Barbara Kolb returned to Tanglewood that year and to Schuler's instruction. In 1968 she was awarded the first of numerous fellowships for extended work at the MacDowell Colony, and in 1970 she was the first American woman to receive the American Prix de Rome. Awards and fellowships from the Fromm, Guggenheim, and Koussevitzky foundations followed in close order. Further awards and commissions came from the National Endowment for the Arts and the Institute of Arts and Letters, as well as composer-in-residence positions at the Marlboro Music Festival and the American Academy in Rome.

Barbara Kolb has reached out significantly to further the cause of new music. From 1979 to 1982 she was artistic director of contemporary music at the Third Street Settlement Music School, presenting the "Music New to New York" concert series. In 1986 she created, under the auspices of the Library of Congress, a music theory instruction program for the blind and physically impaired.

Premiere performances of international importance have marked Barbara Kolb's career: In 1975, the premiere of *Soundings* was given by the New York Philharmonic, conducted by Pierre Boulez and David Gilbert. She composed the score for *Cantico* (on the life of St. Francis of Assisi), the film that won first prize at the 1983 American Film Festival. *Voyants* (1991) was commissioned by Radio France; *Cloudspin* (1991) was commissioned by the Musart Foundation for the 75th anniversary of the Cleveland Museum of Art; and *Millefoglie,* for chamber ensemble and computer tape, was commissioned in 1983–84 for IRCAM in Paris. *The Enchanted Loom*, a commission from the Atlanta Symphony, was premiered by that orchestra under the direction of Robert Shaw in February 1990. She also wrote *All in Good Time* for a 1994 premiere directed by Leonard Slatkin, under commission for the 150th anniversary of the New York Philharmonic.

Kolb's music is notable for its interwoven textures and intense climaxes, finding sources of inspiration in visual images and poetry. Many compositions involve sung or spoken texts, such as *Chromatic Fantasy* and *Songs of an Adieu*. Some of her instrumental works, such as *Appello,* for solo piano, and *Three Lullabies,* for solo guitar, refer to poetic ideas. Visual images, at times a determinant in the meaning of a work by Kolb, appear in the 1979 orchestral work *Grisaille*. It recalls a type of Renaissance painting with a corresponding technique of overlapping musical textures, which then undergo gradual coloristic changes that lead to a violent climax. In the flute and cello piece *Extremes* (1989), the image of opposition dominates the work.

Barbara Kolb has pointed to American jazz as one point of departure, and one may hear jazz inflections in *Homage to Keith Jarrett* and *Chromatic*. According to her personal catalog, provided by her publisher, Boosey & Hawkes, "All of Barbara Kolb's music is infused with French Impressionistic sensibility, which has been distilled, atomized, and overlaid." Hers is a freely atonal yet deeply expressive harmonic language, but it is not without tonal analogues.

Millefoglie, the first score presented here, is a nineteen-minute, one-movement work for chamber orchestra and computer tape. The composer writes:

> *Millefoglie* is a piece concerned with the multiple ways in which [vertical and horizontal] layers of harmonic and rhythmic structures can be superimposed. They constantly undergo expansion and contraction thus creating interplay between the horizontal and vertical layers.

In the Preface, Kolb describes the opening portion of the work,

> a four-minute section, scored for instruments alone without the computer. The basic material is a six-bar rhythmic phrase combined with a chosen set of pitch materials. The rhythmic phrase is presented in the first bars of the piece in its original form. The computer then enters [the end of the present excerpt] creating a supplementary layer above the continual expansion/contraction in the instruments.

> Two lyrical sections follow, the first for computer alone, and the second for marimba, harp, and vibraphone. The central section is an extended five-minute crescendo. It is composed of seven sub-sections of 30 seconds each followed by a final sub-section of 90 seconds. Each of the eight sub-sections is composed of eight harmonic permutations, the last and longest one being a contraction of the material from the seven preceding ones. The crescendo builds to an extreme emotional and dynamic intensity and then, abruptly, a tranquil section concludes the work.

Millefoglie was first performed on 5 June 1985 at the Centre Georges Pompidou in Paris, by the renowned new music group Ensemble InterContemporain, conducted by Peter Eötvös. The work received the Friedheim Award in 1987.

In a note preceding the score of *Voyants*, Peter M. Wolrich writes, "This work evolved from an image of the piano as a voyant ('seer') predicting, imagining, or calling forth dire events. The piece comprises four sections, which follow one another without pause." In the first section, a chromatic crescendo of drama is broken off; in the second, a ruminating and polytonal section fragments the piano "vision"; and a third section of "cataclysmic vision" realizes the piano vision. In the fourth section, the one presented below,

> a piano solo . . . reflects on what has happened. The texture is now homophonic rather than contrapuntal. Interpolations recall the broken, atonal chords of the first section and the harmony of the climactic third section. Calmness has replaced intense

agitation. The upper strings enter with an ascending harmonic progression that is accompanied by descending harmonies in the lower strings. The piano interpolates dissonant reminiscences of the second section. Accompanied by tolling chimes, the woodwinds and strings intone the chord which opened the second section. A final sounding of the chimes stops the woodwinds, and the chord from the second section lingers in the strings and then dies away.

Voyants is dedicated to the memory of Aaron Copland, who died during its composition. It was commissioned by Radio France and was first performed on 23 February 1991 at the Théâtre des Champs-Élysées in Paris by Jay Gottlieb, pianist, the Orchestre Philharmonique of Radio France, and Joel Revsen, conductor. First performances in the United States took place at the Kennedy Center in Washington, in February 1992, and at Avery Fisher Hall of Lincoln Center in New York, in May 1994.

Bibliography

"Barbara Kolb." Publisher's biography and works list. New York and London: Boosey & Hawkes, 1992.

Millefoglie (excerpt)

Barbara Kolb

75

76

84

86

Voyants (excerpt)

Barbara Kolb

92

94

96

Joan La Barbara

(born 1947)

The *San Francisco Examiner* called Joan La Barbara "one of the great vocal virtuosas of our time," celebrating her status as an important pioneer of contemporary art music and sound art, of extended and experimental vocal techniques, including multiphonics (the simultaneous sounding of two or more pitches), circular singing, ululation, and glottal clicks. These have become "signature" sounds in her music.

La Barbara has collaborated on interdisciplinary projects with such visual artists as Lita Albuquerque, Judy Chicago, Kenneth Goldsmith, and Steina and Woody Vasulka. She has received two Meet the Composer/Reader's Digest commissions, one of which was for the Gregg Smith Singers. Other recent commissions include two radio works, a sonic self-portrait (*In the Dreamtime*), and a sound painting of Cologne, Germany (*Klangbild Köln*), from the West-Deutscher Rundfunk-Köln. She composed *Calligraphy II/Shadows*, for voice and Chinese instruments, on a commission for the Nai-Ni Chen Dance Company. Her newest interdisciplinary release is *73 Poems*, a collaboration with the visual and text artist Kenneth Goldsmith. It is an edition of prints with text and accompanying CD, issued by Permanent Press and Lovely Music Ltd on compact disk LCD 3002.

La Barbara's works have been choreographed by John Alleyne for Ballet British Columbia; and one choreographed by Martha Curtis, Catherine Kerr, and Merce Cunningham became an "Events" collaboration. In 1991 La Barbara composed the music for *Anima*, a film produced by Elizabeth Harris Productions. The score calls for voices, Middle Eastern drums, cello, gamelan, synthesizers, computer, and electronic sources. She has written scores for films by Richard Blau, Monica Gazzo, Amy Kravitz, Elise Rosenberg, and Steven Subotnick. She composed and performed the angel voice for actress Emmannuelle Béart in the feature film *Date with an Angel*. La Barbara worked closely with the avant-garde composer and multimedia artist John Cage until the end of his life. She sang in ensembles he directed and premiered some of his works. They collaborated on his final performance, at New York's Central Park on 23 July 1992, which has been released on Music and Arts CD 875 as *John Cage at Summerstage with Joan La Barbara, William Winant, and Leonard Stein*.

In 1977 La Barbara offered a setting of voice with electronic sound for the Signing Alphabet sequence on *Sesame Street*, Children's Television Workshop, to assist hearing children in learning to communicate with the deaf. The sequence has been broadcast worldwide.

La Barbara performed in the opera *Jacob's Room*, by Morton Subotnick, to whom she is married. She appeared in its premiere at the American Theater Festival and in subsequent performances at The Kitchen in New York and at Nice, France, for the European premiere in the 1993–94 season. She premiered Robert Ashley's quartet of operas, *Now Eleanor's Idea*, in 1994.

Joan La Barbara tours in performance and gives workshops on extended vocal technique worldwide. She taught at the California Institute of the Arts from 1981 to 1986, and was artistic co-director of the New Music America Festival in Los Angeles in 1985. She produces and co-hosts a weekly radio program, "Other Voices, Other Sounds." Her recordings range across the new and experimental spectrum, including *Three Voices for Joan La Barbara by Morton Feldman* (New Albion CD NA018), *Joan La Barbara Singing through John Cage* (NA035), and *Joan La Barbara/Sound Paintings* (Lovely Music LCD 3001).

Joan La Barbara was born in Philadelphia, Pennsylvania, with the family name Lotz. She studied voice at Syracuse University with Helen Boatwright and music education at New York University, where she earned a Bachelor of Science in 1970. She took further training in voice with Phyllis Curtin and Marion Szekely Freschl. In 1973 La Barbara assisted in founding the experimental ensemble New Wilderness Preservation Band.

Joan La Barbara has received grants from the National Endowment for the Arts and the DAAD—German government grants to artists in composition, visual arts, writing, theater, and film. As critic and writer, she served as contributing editor for *High Fidelity/Musical America* from 1977 through 1987 and for *Schwann/Opus* since 1995.

The score of "to hear the wind roar" (1991) includes the following commentary by La Barbara:

> When I turned 39 I took up downhill skiing and reaped the unexpected pleasure of the incredible, magical sound at 12,000 feet in the snow—the precious silence, the crack and snap of the snowfield, the gentle ticking of ice-covered branches, the wind whistling through pine needles. I knew I wanted to translate that experience into a vocal piece, blending some of my "extended" techniques with more traditional singing. This work, commissioned by the Center for Contemporary Arts of Santa Fe, I Cantori, and The Gregg Smith Singers, is a single work in three versions: solo voice and tape, small vocal ensemble, and full chorus [the version printed here], all with hand-held percussion. I Cantori premiered the ensemble version May 9, 1992 at Occidental College in Los Angeles and repeated it there October 24, 1992. The Gregg Smith Singers premiered the full chorus version at the Adirondack Festival of American Music on July 18, 1992 and gave the New York premiere March 6, 1993 at St. Peter's Church. The solo version was premiered August 8, 1992 at The Center for Contemporary Arts in Santa Fe; the European premiere of the solo version took place on June 10, 1993 at Podewil in Berlin. The title is taken from John Cage's writing through Henry David Thoreau in "Songbooks."
>
> The commissioning of "to hear the wind roar" was made possible by a grant from Meet the Composer/Reader's Digest Commissioning Program, in partnership with the National Endowment for the Arts and the Lila Wallace–Reader's Digest Fund.

"to hear the wind roar"

Joan La Barbara

© 1991 Joan La Barbara (ASCAP). Used by permission of the composer.

100

"to hear the wind roar"

instructions

↓ = inhaled sound

whistling winds, indicated by S⎯⎯ in score: place tongue in position to make "s" change lip position extremely slowly to extreme pucker on "s", continue gradual lip change for length of breath

ha⎯⎯ = easy exhaled breath only

ü = german or french vowel sound
place lips in position for english "oo"
place tongue in position for english "ee"

(w)⎯⎯ = wind only sound
place lips in position for "w"
blow air through "w" formation, just short of whistling
change breath pressure and intensity through gesture

▼ = sung note as high as possible

pulses in open (unlined) staves are unpitched sounds

ref: p.~ 3

pulsed breath is rapid diaphragmatic expellation of air sound is started and stopped by diaphragm
score indicates if sound is air only or semi-voiced

F⎯ = unvoiced air only through "f" lip formation

ref: p.~ 4

energy shape indicates envelope of energy for entire chorus part indication should provide movement of sound through group

x tuh
place tongue in position to form "l"
move tongue back (away from teeth) until it reaches back of first upper dental shelf
drop or suck tongue away from dental shelf on "tuh"

= slow to fast repetition of sound

↑⎯⎯ = high ululation, pitch not specified like a horse "whinny" but slightly smoother can be thought of as extremely rapid laugh on "hee" each voice continues for length of breath

overtone focussing:
use frontal/nasal resonance chamber
use closed mouth (m) to initiate focus of sound
allow lips to open to "oo", find overtone
gradually move through vowel blends indicated
"rr" sound uses minute myriad muscles at corners of mouth
after reaching "ee" focus (tongue flat against roof of mouth)
use tongue in "y" position to return to "rr" then continue down through "aw(oh)"

= sharp expelling of air w/diaphragm cut-off

= audible exhale/inhale

= multiphonic (notated here on "G")
two ways to approach:
(1) sing normal range pitch but lightly allow sound to "drop" to added octave, continuing to sing upper pitch
(2) start with vocal fry [half-voiced sub-harmonic tone] raise fry to straighten tone (sensation is that of "lifting")

Percussion instruments, played by singers:

= rachet = clave = clapstick
= tibetan cymbal o = egg = rattle
= rainstick

also c# crotale used as ossia to high soprano

= uneven slow to fast, "bouncing ball" effect

Libby Larsen

(born 1950)

According to the *Wall Street Journal*, Libby Larsen belongs to an exclusive club of perhaps two dozen Americans who make a living by writing "serious" music while remaining unattached to an academic institution. Recognized as one of America's "most active and sought-after composers" (*Los Angeles Times*), Libby Larsen has received performances by many major orchestras. She was commissioned by the noted sopranos Arleen Auger and Benita Valente to compose song cycles. Her recent opera *Frankenstein: The Modern Prometheus* was commissioned by the Minnesota Opera and selected by *USA Today* as one of the foremost classical music events of 1990.

Larsen responded with keen insights to questions posed for this anthology:

I cannot speculate on the differences between the way men compose and the way women compose, for that would be speculating indeed. Each composer authors a unique process in which subconscious perception finds its way to practical performance. I have only one general observation about gender which affects the creative process at its heart. This has to do with socialization practices. In our society in general, women are socialized to be the keepers and dispensers of the details of civilization. Ask a room full of women and men who know—at that instant—where the wrapping paper and matching ribbon and greeting cards are in the house, and you will see the women responding with both the answer and the knowledge of what this means. It falls to women, in general, to hold dear all the civilizing details of culture in their heads and hearts. Without those details, the rituals, manners, and ceremonies of human beings in their daily relations would deteriorate quickly.

Why does this affect the creative process? Attending to these details is often considered to be an interruption to those people who have built their working process around large, uninterrupted blocks of time in order to work. Furthermore, these kinds of interruptions are often viewed as necessary but annoying and should be carried out by someone else. Over the past centuries the pattern has been for the male to consume the large block of uninterrupted time, doing "important" work, and the female to carry out the necessary but ancillary details of civilized living—"detail." Society in general judges that someone working in protection on a large thought is doing better, more-concentrated work than someone who is physically carrying out other tasks while occupying their mind with large thoughts. Hence you have an essay like Virginia Woolf's *A Room of One's Own*. Some women try to construct the male model of

large, uninterrupted blocks of time in which to consider thoughts of genius. Until recently, this manifested itself often in women telling other women that, if they wanted to do "serious work," they must not marry or have a family. To marry and have a family is to become irrevocably responsible for the ownership and dispensation of detail. Unless one was wealthy and could hire a housekeeper, this was the truth. At its heart, is the creative process affected by the expectation of how one will work on the creative problem? My answer is yes.

In a radio interview in Billings, Montana, in 1991, Libby Larsen talked with Cynthia Green:

CG: Did you have any role models of women composers?

LL: No, I had no role models of women composers. The only composer who was a woman whom I had heard about was Pauline Oliveros. And now, she's a friend. But at that time I just knew *about* her. . . . Then I heard about Thea Musgrave, who is now also a friend. And her music was closer to what I looked for. . . . It never really entered my mind that there were any issues surrounding the fact that I was a woman and that I was a composer . . . until a graduate class, when a male colleague pointed out to me that I would be unable to compose in large forms because I was a women.

CG: And what was his reasoning for that?

LL: That women couldn't think in large, logical structures.

CG: [Laughs] Oh, you certainly have put him to shame many times over.

LL: Well, he became a doctor.

Further reflecting on issues to be dealt with in this anthology, Libby Larsen asked,

What is the greatest challenge facing a contemporary composer? It is the challenge of musical language. The question is "in what language do I speak and to whom do I speak?" In the last half of this century sound has become portable. Personal music collections have become multilingual. Listening has evolved into a customized individual experience. The choices for us composers are vastly different from even twenty years ago. I have responded by taking a point of view and delving deeply into my own spirit to be as honest as I possibly can in each and every piece I compose.

How would I like to be viewed by the present and future? In the present, I hope that I am viewed as an interesting and respected voice and as a composer who loves and respects the live concert tradition.

The voice as "crier of the spirit" and the spiritual component of music composition, occupies Larsen's thought. In discussing her work *who cannot weep, come learn of me*, she recalls singing Gregorian chant as a child, when

second-, third-, and fourth-graders would sing for funerals. Gregorian chant isn't conducted—it's shaped by the moment, and it's shaped by the spirit. And the people were very stoic. Even opening the coffin, very stoic—they would look down and nod. But invariably, when we got to the *In Paradisum*, people's knees would buckle, they would break down crying. These were second, third, fourth graders—it's about as pure as you can get. It was pure grief, and it was pure beauty. . . . For me, that's spirituality. And in every piece I write, if I can't get close to it, I can't love the piece.

How it Thrills Us honors the tradition of the Kings College Choir, for whom it was composed,

I was most interested to honor the mystery of the voice as the ancient crier of the spirit. Also, I have a deep love for physical acoustics and an abiding awe for the symbiotic evolution of musical language and performance space. It is literally thrilling to me to hear tonality suspended in air in the decay of a sound in space. In *How It Thrills Us*, I set out to create music which hangs in space and memory while the music in real time moves on. I let major thirds suspend in the air while related major thirds were being sung. As the piece continues, related thirds become chords of stacked thirds juxtaposed with other chords of stacked thirds in space and time. The tonalities and use of both suspended and real time enhance the translated poem, particularly the phrases "Cry chance in" and "Where are we?" To create a foundation in which to perceive the aforementioned, I added a dancelike figure which suggests accompaniment and a tonal center."

How it Thrills Us was commissioned in 1990 by the Plymouth Music Series for the 500th anniversary tour, the next year, of the King's College Choir. Larsen says,

There is nothing more mystical than the voice raised in free expression. Now, more than at any time in my life, I feel the importance of this. *How It Thrills Us*, Rainer Maria Rilke's poem [from *Sonnets to Orpheus*], speaks of the "cry"—any cry that was always there. Today there are many, many cries around us, always there. Only some are human. Where are we?

She states frankly, "I have not entered the work in contests because I do not enter contests."

What does the piece mean to me and why did I suggest it to represent an essential expressive idea? What a question! I expressed a personal spirituality in *How It Thrills Us* and I worked with a poet whose writing moves me deeply.

To me, composing is to speak an abstract acoustic language which presents an order of sound in space as an expression of time and spirit. *How It Thrills Us* does this. I hope that each one of my compositions does this in some way. It's not necessary that they sound consistent in musical language.

In his analysis of the composition, Douglas R. Boyer shows that it reflects the sonnet structure of the poem, in the following scheme:

$$\text{Introduction} \quad A^1B^1 \quad A^2B^2 \quad A^3B^3 \quad A^4B^4 \quad A^5 \quad \text{Coda}$$

According to Boyer, *How It Thrills Us* is a study in polymodality, with E-flat being central but with false relations, or tones, outside that center. At m. 7 the strong presence of A-natural suggests E-flat Lydian, but the pitch collection is refocused into D Phrygian soon afterward. Beginning at m. 25, augmented sixth chords are introduced, and there is a modulation to F Lydian. Pivot-tone modulation then returns the center to E-flat.

Sound color, such as here of the voice, is a predominant consideration in Larsen's' music and in *How It Thrills Us* especially. In the radio interview quoted above, she was asked if she is attracted by any particular quality in a piece of music.

Yes, I look for color, first and foremost, which is why I can play a CD of Debussy, followed by James Brown, followed up by Hank Williams. . . . Secondly, I look for a healthy struggle for rhythm to get out. . . . I am very much a child of rhythm, and less a child of melody, even though I grew up as a singer. . . . I am much more interested in the parameter of rhythm and its emergence, really, over the parameter of melody

in this century. And so . . . I look at Berlioz, I look at Debussy. I look at Stravinsky too, of course.

Bibliography

Boyer, Douglas R. "Musical Style and Gesture in the Choral Music of Libby Larsen." *Choral Journal* 34/3 (October 1993):17–24.
"Classical: Batons Hint at a Brave New World." *USA Today,* 24 December 1990, 2D.
Herman, Kenneth. "Classical Music Has Found a Good Home." *Los Angeles Times*, 11 March 1986, Part VI, p. 3.
Lambert, Pam. "Orchestrating a Life in Music." *Wall Street Journal*, 9 August 1988, "Leisure and Arts," p. 21.
Larsen, Libby. "The Nature of Music." *Pan Pipes of Sigma Alpha Iota* 77 (Winter 1985):3.
Larsen, Libby, with Victoria Bond. Interview, "Towards Creating a Composer-Friendly Environment." 19 April 1990. Roanoke Symphony Orchestra, Roanoke, Virginia.
Larsen, Libby, with Cynthia Green. "Interview with Libby Larsen." *ILWC Journal* June 1992:24–27.

Discography

How It Thrills Us. King's College Choir, Stephen Cleobury, director. EMI Classics, CDC 7 54188 2, D 567 FPM 518.

113

115

117

Hope Lee

(born 1953)

Hope Anne Keng-Wai Lee was born in Taipei, Taiwan, to parents originally from mainland China. In her autobiography, she describes herself as a cross-cultural explorer for whom creativity is an endless adventure of exploration, research, and experimentation:

> Things change constantly and continuously; therefore, each work should be approached from a fresh angle. Growth is a natural phenomenon reflected in my compositional technique. Not unlike disciplined organic growth—a most fascinating phenomenon— it is the secret of life, the source of true freedom.

Lee moved to Canada in 1967, and became a Canadian citizen in 1974. She had intended to study medicine, but her bachelor's and master's degrees at McGill University in Montreal were in music. She received a DAAD grant and a grant from the Canada Council to attend the Staatlich Hochschüle in Freiburg, Germany. Her primary composition teachers were Bengt Hembraeus, Brian Cherney, and (in Germany) Klaus Huber. Two early and formative experiences were her participation in the Darmstadt Ferienkurse für Neue Musik and the 1979 Oriental Music Festival in Durham, England. The latter inspired her to include more of Chinese culture in her art. Lee enjoyed composer residencies at the Künstlerhaus Boswil in 1986–87, in Switzerland, and at Queen's University in Kingston, Ontario. From 1987 to 1990 she studied Chinese traditional music and poetry in Berkeley, California. She presently resides in Calgary, Alberta, where she works as a free-lance composer and is also affiliated with Mount Royal College. She is married to the composer David Eagle.

Hope Lee's music has been performed at festivals throughout the world, including Music Today in Tokyo, World Music days of the International Society of Contemporary Music in Germany, Aspekte Salzburg Festival, and the Hong Kong Festival. Her works have received first prize at the 1979 PROCAN Young Composers' Contest; at the 1991 Scotia Festival for *Nabripamo* (1982), for piano and marimba; and at the 1989 International Composers Competition in Budapest for "...I, Laika..." (1989), for flute, cello, and piano. Other principal works include the *Ballade of Endless Woe* (1979), for vocal quartet and percussion ensemble; *Onomatopoeia* (1981), for chamber orchestra and children's choir; and *Melboac* (1983), for harpsichord.

Since 1979 Lee has concentrated on studies of ancient Chinese poetry, music his-

tory and theory, philosophy, and musical notation for traditional instruments. That for the ch'in, a seven-string zither, has particularly occupied her, and she is notably proficient on the instrument. With that immediate experience, she has envisioned a series of eleven works reflecting her Chinese background and cultural interests. She has completed five: *In the Beginning was the End* (1989), for accordion and harpsichord; *Hsieh Lu Hsing* (1991), for guzheng and either di, shao, or er hu; *...entends, entends le passé qui marche* (1992), for piano and tape; *Tangram* (1992), the work included here, for bass clarinet, harpsichord, and tape; and *Voices in Time* (1994), for large ensemble, tape, and electronic sound.

Lee's music is complex and atonal but, according to Kevin Bazzana in *Encyclopedia of Music in Canada*, it is also propulsive and forcefully expressive. Lee consistently explores new electronic sound resources and new uses of acoustical instruments, and on several occasions she has been drawn to multimedia presentations.

Hope Lee sees her works as incorporating the traditional with the new:

> For me, this is the real Chinese music . . . not the cliché pentatonic Chinatown stuff. Contemporary music has drawn on elements from other non-Western traditions, such as gamelan music and Noh drama, but not classical Chinese music. So I've met with musicologists and ch'in players to learn . . . and I plan on incorporating this material.

In an interview in *The Canadian Composer* in 1988, Lee challenges current composers to reach toward new audiences: "We need a new kind of presentation, not the 19th-century forms . . . but something appropriate for our times. There isn't enough communication between contemporary composers and audiences." The interviewer, Michael Schulman, illustrates her approach by citing the 90-minute, multimedia presentation *Lumina*, given at Toronto in 1988. The work is a striking collaboration by three composers—Lee, David Eagle, and David Keane; librettist Melba Cuddy; light artist Robert Mulder; and vocalists of the early music Toronto Consort. Lee's segment, entitled *In a Mirror of Light*, created new music by drawing on medieval sources and incorporating fourteenth-century works. The inspirations for the collaborative effort were the artistry of Gothic stained glass windows and the technology of contemporary sound. "Illuminating" the music at the premiere was an ever-changing visual display, produced by means ranging from candles to computer-controlled projections, creating the image of a giant stained glass window.

Lee says that her "approach to composition involves three aspects—personal, musical, and social. For me, the personal aspect is not so much self-expression as the chance to unify what I call 'outer being' with 'inner being,' to create a harmony between the two."

In the Schulman interview, she is forthright in revealing her compositional process:

> The T'ang Dynasty poet Li Po wrote that all poetry is just floating in the air, waiting to be plucked by a pair of lucky hands. So I plan things well in advance, the concept, the structure, working out the ideas in my mind, asking myself what I can do in this piece, how I can go a bit further. Once the ideas are very concrete, I start writing, and it comes very fast. . . .

> The social aspect of composing is also very important for me. I feel that artists should not only reflect their own times and their own surroundings in their work, but they

should also lead their times. I don't like to use the word "educating," but artists should be awakening people to circumstances, inspiring them, leading them to new areas, new concerns.

Tangram was commissioned and premiered in 1992 by the Dutch harpsichordist Annelie de Man and the bass clarinettist Harry Sparnaay. A prerecorded tape based on water sounds from Kananaskis, in the Chinese tradition, is played in conjunction with the acoustic instruments. In a program note included with score, Joost Elffers writes:

> The square is as high and as wide as a man with outstretched arms. In nature the square can be found in numerous minerals. The square, as was believed in olden times, had the strength to protect one from illness. The Chinese division of the square into the tangram allows the regrouping of elements to form hundreds of figurations and abstract forms. Through a continual rearrangement of its form, the tangram attempts to lift up its own form.

The tangram is a Chinese geometrical puzzle made from a square cut into five triangles, a square, and a rhomboid, which can be combined to make two equal squares or to form several hundred other figures. As the composer states in a direct communication,

> In this composition music material is like the seven magic pieces found in tangram. Through arrangement, shaping, and regrouping, images appear and impressions are left.

> Relating to tangram, seven musical gestures were assigned to the bass clarinet and harpsichord. For the clarinet, a square was represented by a multiphonic, chorale texture; an upward triangle was translated as an ascending line up to a high, pure, tone; and a downward triangle was represented by pure tone followed by a descending line to low notes. . . .

The figures making up the harpsichord part have a similar structure, with segments lettered *a* through *g*.

The structure of *Tangram* is formed by focusing the seven segments in the order *a, e, f, b, g, d, c*. The tape part serves as a bridge between the two instruments, with very different timbre, and it suggests the possible existence of another dimension—both in timbre and in space.

The score provides the following instructions on performance and notation:

Accidentals apply to the notes they immediately precede and to repeated notes.

note duration / pause	● ╱ ╮	1.5" - 3.5"
	○ ╱ ╮	4.0" - 5.5"
	○• ╱ ╮	5.0" - 7.0"
a group of notes	♫♫♫♫	moderately fast
	♫♫♫♫	faster
	♫♫♫♫	fastest
	◤ ◤	accelerando
	◣ ◣	decelerando

Bibliography

Bazzana, Kevin. "Hope Lee." Entry in *Encyclopedia of Music in Canada*. 2d ed. Toronto: University of Toronto Press, 1992.

Lee, Hope. *Autobiography*. Kassel, Germany: Furore Verlag, n.d. Furore Verlag is the primary publisher of Hope Lee's scores.

Schulman, Michael. "Interview with Hope Lee: In Search of a New Way." *The Canadian Composer*, March 1988, pp. 14–16, 28–29.

Tangram

Hope Lee

127

128

129

Nicola LeFanu

(born 1947)

> I believe, with Margaret Mead, that any art is much richer, much stronger if it is practised by both sexes. If music has anything to offer this destructive, divided society of ours, won't it need to spring from both men and women, rather than continue to reflect patriarchy back at itself?

Nicola LeFanu made these remarks in an article published in *Contact*. She then went on to argue that the act of highlighting women composers remains of vital importance in the present day. "In my thought and actions there is much that is similar to a man's, but much more that is different. Can it really be otherwise in my music? Could there be a music that did not reflect its maker?"

LeFanu reflected upon her naiveté of the 1970s, when she arrived on the scene as a young woman believing that discrimination against women in music, such as occurred in the generation of her mother (the composer Dame Elizabeth Maconchy), was a thing of the past. In the same 1987 article, she says,

> I could never have imagined the effects of the oligarchy of the 1980s. . . . The London Sinfonietta is Britain's leading new music ensemble, which would have played about 250 hours of live music [in the 1980s]. So how much time did it make for contemporary women composers, who number about 15% of British composers working today? Sadly, I found only 15 minutes.

Women composers at present are faced with two kinds of prejudice, "the overt discrimination of the misogynist [and] a 'systematic discrimination': the way the system is loaded against women." Even so, from the perspective of 1987 she could conclude with a certain hopefulness: "There has been general recognition that these are as much issues for men as for women. . . . No one benefits from a culture which is narrow and confused."

In a 1984 interview in *Contemporary Music Review*, concerning her opera *Blood Wedding*, LeFanu maintained her stance on the need for championing women's music, emphasizing however the need for mainstreaming:

> I care passionately about equal opportunity, and I've given a lot of time to it. . . . You cannot combat sexism with sexism. I'm interested in the women's movement as an

instrument of social change, not as a separatist movement. I am optimistic for the future, musically. . . . Among performers there are many in whom I feel great faith. For myself, optimism and pessimism are irrelevant . . . I write music and do too much else besides. . . . Composing, even at its most intractable, is like breathing.

Nicola LeFanu was born of Irish parents. She studied composition first at Oxford University, then traveled to the United States as a Harkness Fellow. At Yale University she studied with Earl Kim, who introduced her to Asian and specifically to his ancestral Korean music culture.

When LeFanu began to have her own composition students, she became aware of the importance of her mother as role model. She also maintains an important friendship with composer Gillian Whitehead, whom she met in 1969 and whose music she continues to admire. "I suppose she is the composer to whom I feel most close, really out of my love for her music. I think she's an extraordinarily fine composer" (as quoted in the journal *Music in New Zealand*).

LeFanu's catalog consists of over 50 works, including music for orchestra and chamber groups, many works for voice, and several operas—"opera is very addictive to me." These include a chamber opera on American Indian texts, *Dawnpath* (1977); the monodrama *Old Woman of Beare* (1981); the radio opera *The Story of Mary O'Neill* (1986); and a children's opera with libretto by Kevin Crossley-Holland, *The Green Children* (1990). More recent operas are *Blood Wedding* (1992), to a libretto by Deborah Levy after Federico García Lorca; and *The Wildman* (1994) to a libretto by Crossley-Holland that is based on a thirteenth-century chronicle. LeFanu is married to the Australian-born composer David Lumsdaine and has a son, Peter. After seventeen years as Professor at King's College London, in 1994 she became Professor of Composition and Head of the Department of Music at the University of York.

LeFanu writes in *Contemporary Music Review* that her first encounter with opera came at age four, when she was spellbound by *Hansel and Gretel*. She wrote and produced plays throughout her childhood, never doubting that she would be a playwright when she grew up. At seventeen she produced *The Marriage of Figaro*, and she considers Mozart's operas a touchstone of her life.

> *The Old Woman of Beare* remains a favorite of mine, partly because it brings together dramatic and lyric aspects of my work, partly because it could only have been written by a woman! It is a passionate, autobiographical poem written in Ireland about a thousand years ago. The original uses [the ancient Irish language] in an extraordinary way; it seems to capture the very sound of the sea on Ireland's wild Atlantic coast. I wrote my own version in English, but I drew particularly (with his permission!) from Brendan Kennelly's beautiful free translation (*Penguin Book of Irish Verse*).
>
> I dreamt of *The Old Woman of Beare* and made studies for it for about a year, but I didn't want to start it without a performance in view. Then Cha-Chi Martinez offered me the opportunity, and I wrote it in about six weeks. . . .

In a separate communication LeFanu writes,

> In effect the opera was composed for the celebration of the 50th anniversary of the Macnaghten Concerts, at the invitation of Odaline de la Martinez, musical director of the contemporary music ensemble Lontano. It was premiered at St. John's Smith Square, London, on 3 November 1981. It has been reasonably well reviewed, but I do

not keep [the reviews]. English musical journalism is not for posterity—it is just hasty impressions. . . .

In the published performance directions for *The Old Woman of Beare*, the composer writes that

> the first percussion player should treat the part for hourglass drum as a solo part throughout. A suitable drum . . . should have a wide pitch range and be extremely flexible; it should also have a wide dynamic range. The ethnic origin of the drum is not important provided it "speaks" well.

LeFanu advises the soprano to memorize her part and prepare it as one would prepare a part in a play. The soprano part should be amplified unobtrusively; amplification is especially important for the spoken sections and permits the performer to speak extremely quietly without "stage" projection. In a personal communication LeFanu says,

> I love to write for voice, and *The Old Woman of Beare* is a good example of how I like to integrate all that the voice can do, moving seamlessly through speech, heightened speech, speech/song, song—song from its simplest articulations into full-fledged aria.

Bibliography

LeFanu, Nicola. "Interview with Nicola LeFanu." *Contemporary Music Review* 11/1–2 (1994):183–87.
LeFanu, Nicola. "Master Musician: An Impregnable Taboo?" *Contact* 31 (Autumn 1987):4–8.
LeFanu, Nicola, with Dorothy Ker. "A Conversation with Nicola LeFanu." *Music in New Zealand*, Spring 1995, pp. 24–26.

The Old Woman of Beare (conclusion)

Nicola LeFanu

No_____ cros-sings_____ now_____ for Bu-i___ no

more sail-ings on youth's sea Now

V

Can-cer the crab the crab crawls___ through my blood

136

280

137

tide ___ that made me ___ stretch at ___ the side ___ of ___ him who'd take me brief -

140

142

145

lea-ving me a des-pic-a-ble weed

150

151

335

152

340

Voice: far-ther it goes ... leav-ing me here __ where the foam dries __

345

Voice: __ on the emp-ty strand __ Dry as my veins Dry as my lips

Very old, very detached
Spoken

153

154

Tania León

(born 1943)

Tania Justina León was born in Havana, Cuba, of French, Spanish, Chinese, and African descent. She began piano study at age four, and went on to graduate from the Peyrellade Conservatorio de Música in Havana, with a Bachelor of Arts in 1963 and, later, a Master of Arts in music education. She began her career as pianist in Cuba. She moved to the United States in 1967 and studied composition with Ursula Mamlok at New York University, earning a Bachelor of Science in 1971 and a Master of Music in 1975.

Tania León has had a long-standing association with the Dance Theatre of Harlem as pianist, conductor, and composer, and she founded its music school and orchestra. She has conducted the Metropolitan Opera Orchestra, the Gewandhausorchester Leipzig, the National Symphony Orchestra of South Africa, the New World Symphony, and the Louisville Orchestra; and in 1992 she became Associate Conductor of the Brooklyn Philharmonic Orchestra. As J. Michele Edwards notes in *Norton/Grove Dictionary of Women Composers*, León is Professor of Music at Brooklyn College, having taught there since 1985; and has been visiting lecturer at Harvard and Yale universities.

As of this writing León is Revson Composer Fellow of the New York Philharmonic, in which capacity she serves as New Music Adviser to the orchestra. She toured Europe in fall 1995 with the orchestra, at the invitation of director Kurt Masur, and conducted the orchestra in performances of her works in Spain and Germany. Her first opera, *Scourge of Hyacinths*, was commissioned by the City of Munich and won the BMN Prize for Best Composition at the 1994 Munich Biennale for the New Music Theater. She wrote the libretto for the work, based on the play by Nobel laureate Wole Soyinka, and conducted the premiere.

León has received composition awards from ASCAP, the National Endowment for the Arts, Meet the Composer, Chamber Music America, and the American Academy of Arts and Letters. She has received fellowships to the MacArthur Foundation at Yaddo and the Rockefeller Foundation at the Bellagio Festival in Italy.

Recent commissions also include *Drumming*, an interactive work in collaboration with choreographer Bebe Miller and video artist Phillip Mallori Jones; a work for the men's vocal ensemble Chanticleer; a song cycle entitled *Singin' Sepia* in collaboration with the poet Rita Dove; *Para Viola y Orquestra* for a consortium of four American orchestras; and *Hechizos* [Spells], commissioned by Berlin's Ensemble Modern, which premiered it in March 1995.

Tania León's compositional language incorporates elements of her native Cuba, jazz, and Africa alongside strongly contemporary idioms. The intervals of the second and seventh, as well as colorful orchestration and a powerful rhythmic sense, infuse her work. *Momentum* (1986) for solo piano, was written for Yolanda Liepa, dedicated to the composer Joan Tower, and commissioned by the Women Composers Congress of Mexico. The work was described in *Newsday* as

> a brief, dense synthesis of American, Latin, and international styles. After one echoing note produced by holding a string inside the piano, the work combines what sounds like serial tone rows with touches of Latin dance rhythm, stride piano, and blues. . . . It is thick, intense, and highly personal.

Momentum

Tania León

158

161

Alexina Louie

(born 1949)

Alexina Diane Louie was born in Vancouver of Canadian parents of Chinese descent. In her youth she concentrated on piano studies. She turned to composition as an undergraduate but supported herself by playing cocktail piano in Vancouver's leading hotels. She earned a Bachelor of Music from the University of British Columbia in 1970 and a Master of Arts in 1970 at the University of California–San Diego. For the latter degree, Louie studied with Robert Erickson and Pauline Oliveros.

From 1971 to 1974 Louie was a member of The ♀ Ensemble, directed by Pauline Oliveros and conceived around the performance of meditations through sound and movement. Similar explorations of spiritual or other, less-tangible aspects of music have continued to influence Alexina Louie's compositional thought. For example, in her four-channel tape work *Molly* (based on James Joyce's *Ulysses*), Louie explores ways of making the electronic medium sound "human." Throughout the 1970s she studied Asian and particularly Chinese music with Tsun-Yuen Li. *Lotus* and *Lotus II*, for tape, reflect the sound and structure of the Indonesian gamelan ensemble; and in more recent works, Louie explores atmospheric and evocative sonorities, using bell-like or gong sounds played by augmented but restrained percussion sections.

Alexina Louie taught piano, theory, and electronic composition at Pasadena City College from 1974 to 1980, and at Los Angeles City College from 1976 to 1980. She returned to Canada in 1980 and has made Toronto her home ever since. She has focused on combining the Asian sense of timbre, which was refined by serious study, with avant-garde techniques. As her style has evolved, it incorporates the traditional structures of Bach, Mozart, and Mahler, without forsaking her emphasis on unimpeded, expressive communication. For example, *O Magnum Mysterium: In Memoriam Glenn Gould* (1982), for 44 divisi strings, includes quotations from Bach and Mahler. It was performed by the BBC Symphony in 1993 and by the St. Louis Symphony, under Leonard Slatkin, in 1994.

In important compositions such as *The Eternal Earth*, Louie expresses her concern over the threat to the environment. Her *Songs of Paradise* of 1989 received the highly prestigious Juno Award in the same year; and since 1992 she has twice received the SOCAN Award as the Canadian composer most frequently performed in a given year. Recently, she has received several notable performances and commissions. *The Ringing Earth*, commissioned for the gala opening of Expo 1986 in Vancouver, was also

performed by the Montréal Symphony on United Nations Day, 1986. Louie's string quartet *Dénouement* (1994) was commissioned for the Vancouver Chamber Music Festival; and her violin concerto, *Thunder Gate*, was premiered in 1995 by soloist Martin Beaver and the Toronto Symphony. Alexina Louie's career shows a mushrooming of performances and awards: in 1995 alone, four of her works have appeared on compact disks.

"Ritual on a Moonlit Plain" is the first movement of *Music from Night's Edge* (1988), for piano quintet. The remaining movements are "Midnight Music," "Interlude: Heavenly Light," and "Quicksilver Light." Louie writes in the score:

> The many visions engendered by the night have become the initial stimuli for a number of my works. In particular, *Music from Night's Edge* covers a wide range of night images, from a primitive ritualistic dance on an empty, stark, moonlit plain to the mysterious personal intensity of the second movement, a glimpse into the starry night to, finally, the bright flickerings of moonbeams on a windy night sporadically glancing off rustling leaves and illuminating rocks, a spot of earth, trees, wildflowers, a path through the forest. On a second level the work at times explores the edge of madness, from the pagan dervish music of the first movement through the internalized passion of the second and finally the quirky, somewhat schizophrenic nature of the fourth.
>
> In 1986 the Canadian Music Council named the Orford String Quartet, Angela Hewitt, and myself respectively as the Ensemble, Performer, and Composer of the Year. *Music from Night's Edge* was commissioned by the Orford String Quartet through the assistance of the Ontario Arts Council to celebrate the happy occasion.

Discography

"Ritual on a Moonlit Plain," from *Music from Night's Edge*. On *Alexina Louie, a Self-Portrait*. Canadian Broadcasting Corporation. Cassette tape distributed by The Canadian Music Centre/Le centre de musique canadienne. 20 St. Joseph Street, Toronto, Ontario, Canada M4Y 1J9.

Ritual on a Moonlit Plain

Alexina Louie

© 1988 Alexina Louie. Used by permission of the composer.

*repeat figure as quietly as possible

171

*hold pitch before starting the glissandi

Elisabeth Lutyens

(1906–1983)

Agnes Elisabeth Lutyens, the daughter of the architect Sir Edwin Lutyens, was born and died in London. Her study of music began at the École Normale in Paris, but in 1922 she transferred to the Royal College of Music in London, where she studied composition and viola. As Anthony Payne observes in *Norton/Grove Dictionary of Women Composers*, Lutyens's stylistic evolution was slow and arduous. Her introduction to the Purcell string fantasias led her to an independent view of part writing, and from there to a personal brand of serialism, beginning with the Chamber Concerto No. 1 (1939).

At this time Lutyens was experiencing a marked dissatisfaction with the British musical establishment, and she was encountering turmoil in her personal life. In 1939 she left her first husband, Ian Glennie, for the BBC program organizer Edward Clark. As Clark never held a steady job, Lutyens was compelled, for over twenty years, to write film and radio music to support her four children. Some feel that this situation hindered her development, and Lutyens did not value her commercial compositions as artistically significant.

During the Second World War, Elisabeth Lutyens made a wide exploration of styles, including Romantic expressionism and neo-Classicism. By the end of the war she had developed a personal manner of using serialism, notably in her setting in 1946 of Rimbaud's *O saisons, o Châteaux!*, a cantata for soprano with chamber orchestra. Her maturity is reached in such compositions as the Concertante for Five Players and the Sixth String Quartet of the 1950s, which exhibit sparseness of texture, rhythmic freedom, and independence of parts.

Despite the new surety of her idiom, Lutyens's music of the 1950s suffered from almost total neglect, since serialism was viewed in England with reprehension. In the 1960s, however, Lutyens received a certain measure of recognition. According to Anthony Payne, in the mid-1960s her music saw a change of direction. There was a widening of vocabulary, admitting repetition and simple patterns, and pictorial or atmospheric writing coexistent with the abstract. Her 1968 work for chorus and orchestra, *Essence of Our Happiness*, incorporates crucial silences, sparse textures, and, as Payne notes, "repetition and reduced eventfulness carried to daring limits . . . giving a sense of timelessness. . . ." In the late 1960s, Elisabeth Lutyens created a series of works for the musical stage, including the musical charade *Time Off? Not a Ghost of a Chance!* and the operas *The Numbered* and *Isis and Osiris*. In 1972, Lutyens embarked

upon a series of works by the title *Plenum*, which incorporate her full freedom of notation, rhythmic flexibility, and time sensibilities. The first of these pieces, for solo piano, is presented here.

In 1969, after thirty years of pronounced achievement and excellence, Lutyens finally received official recognition, with the City of London Midsummer Prize and the award of Commander of the Order of the British Empire.

Plenum I

Elisabeth Lutyens

182

* CENTRE PEDAL.- - -

184

LONDON, MAY 1972

Babbie Mason

As she describes it in her autobiography,

> A typical day in the life of Babbie Mason sounds a lot like an ordinary working life and mother. She rises early to get their youngest son, Chaz, off to school and goes off to the office. After school she prepares dinner and finishes the evening carpooling Chaz to ball practice, choir rehearsal, and Little League games. . . . Besides her priorities of wife and mother, she has made approximately 100 worldwide concert appearances annually. She is a prolific songwriter as well. . . . Her most recent recording makes a total of eleven projects [of multiple songs] to her credit.

Such attention to prioritizing, as Babbie Mason relates in a personal communication, was instilled from an early age. Raised in Jackson, Michigan, the daughter of a pastor, she served as church pianist and choir director for nearly twenty years. Even at age nine she had the remarkable responsibilities of playing for three choirs and participating in live radio broadcasts. Mason signals the diversity of her background as a child and young adult, including her upbringing in a black Baptist church, college education at a Free Methodist college, and early career as a public school teacher. Although she travels and concertizes extensively, she remains dedicated to her own community. On a regular basis she visits youth detention centers, women's jails, prisons, and teen-age crisis pregnancy centers. In all settings, she works to encourage people "by showing them that, regardless of circumstances, through Christ, they can lead a life of purpose." At present Mason lives in the Atlanta area with her husband, Charles, who is her manager, and their family.

Her years of training have deepened her commitment

> to God, family, and ministry. I realize that ministry does not begin and end on stage . . . which is only a small part of the overflow of what is happening in everyday life. Ministry begins at home and spreads abroad. I must take time to be home with my family, and I recognize the importance of being involved in the life flow of my home church, where I often lead the praise and worship. It is imperative that I find opportunities to receive so that I have something to give away.

Compositions by Babbie Mason that have made a significant impact, as evidenced by their distribution across the United States, include "All Rise," "Each One Reach One," "With All My Heart," "God Has Another Plan," and "The Sea of Forgetfulness," a recent, top single in Contemporary Gospel, recorded by Helen Baylor. Besides her

own recordings, Mason's compositions have been recorded by such distinguished artists as Larnelle Harris, Michael English, The Brooklyn Tabernacle Choir, Scott Wesley Brown, TRUTH, Albertina Walker, and O'Landa Draper and The Associates.

The recording project *Standing in the Gap* (1993), of which the following score is the title song, occurred to the composer as she observed others struggling in their personal lives.

> I felt compelled to encourage and restore them and, above all, pray for them. . . . I felt this message was so big and powerful that I didn't want to say it alone. I wanted friends to stand with me to make this statement. Helen Baylor and Cindy Morgan [who appear in the recording with Mason] do an outstanding job of saying with me, "Whatever it is you're going through, I will not condemn you, but love you and pray for you." I believe this song will serve as a message of hope to those who find themselves in seemingly hopeless situations.

Standing in the Gap poignantly addresses other priorities for the believer: trusting God, faithfulness, repentance, sharing one's faith, and coping with human injustice.

Discography

"Standing in the Gap for You," on the cassette tape *Standing in the Gap*. Word Records 7019384501. Distributed by Word Records and Music, 3319 West End Avenue, Nashville, Tennessee 37203. Requests for further information may be communicated to Babbie Mason Ministries, 1480-F Terrell Mill Road, #291, Marietta, Georgia 30067, phone (770) 952–1443.

Standing in the Gap for You

Words and music by Babbie Mason

With sincerity ♩ = 72

© Copyright 1993 Word Music (a division of Word, Inc.)/May Sun Music (adm. by Word, Inc.)/
ASCAP. All rights reserved. Used by permission.

192

193

Joni Mitchell

(born 1943)

Roberta Joan Anderson was born in Fort Macleod, near Lethbridge, Alberta, Canada, and was raised in Saskatoon. As a child she developed interests in painting, poetry, and music, all of which she would apply in her artistic career. She studied piano for a time, but turned to the guitar in the early 1960s. As a student at the Alberta College of Art in Calgary, she sang in a local coffeehouse. When she moved to Toronto, she continued performing in coffeehouses and wrote her first songs in that context, including "Day by Day" and "Play Little David Play."

In 1965–66, while married to the American folksinger Chuck Mitchell, she lived in Detroit and concertized in the northern part of the United States. Joni Mitchell first appeared in a national setting at the Mariposa Folk Festival in 1965, and she returned to sing there the next year. In the Toronto *Daily Star* of 6 August 1966, critic Arthur Zelden wrote that "Miss Mitchell plays the guitar tolerably; her voice is an interesting, although not unusual version of Joan Baez's. The songs that she writes and delivers so feelingly, though, are lovely, poetic, even Canadian in their tone."

Early recognition came to Joni Mitchell through her own singing and that of established singers such as Tom Rush, Ian and Sylvia, and Buffy Sainte-Marie. But it was the recordings by Judy Collins and others of Mitchell's "Both Sides Now" that first brought international fame. Mitchell started performing in important festivals in the United States and Europe, including the Miami Pop festival, Newport Folk Festival, and Isle of Wight Pop Festival. She moved in 1966 to New York and then in 1968 to Los Angeles, which remains the base of her career.

After an international tour in 1983 Joni Mitchell ceased appearing widely, choosing instead to participate only in special projects, often for particular social causes. For instance, in 1985 she appeared at the University of Illinois Farm Aid project and in 1990, in Roger Waters's Berlin production *The Wall*, a benefit for international disaster relief. She continues to record her own songs, and for most of them, she writes both lyrics and music. On many occasions she designs the record jackets of her remarkably successful albums and oversees their production. Other international artists who have sung and recorded her works include Bing Crosby; Frank Sinatra; Crosby, Stills, Nash, and Young; and Sergio Mendes and Brazil '66.

Mark Miller, in *Dictionary of Canadian Music*, observes that Mitchell's songs are often autobiographical, drawing attention to her personal life. However, the vivid im-

pressions evoked by her lyrics and music address the concerns of a very wide audience, who identify closely with her sentiments. Her melodic idiom is remarkably compelling; she is able to elongate or bunch, fragment, or broadly lyricize her texts. The close kinship of the lyric and the melody setting has frequently been remarked.

Her earliest idiom was folk-based and permeated the albums *Clouds* (1969) and *Ladies of the Canyon* (1970). Mitchell evolved in the 1970s, essaying a distinct jazz idiom in *Court and Spark* (1974) and, in collaboration with jazz bassist Charles Mingus, the album *Mingus* (1979). Her albums of the 1980s, which seem to have been influenced by her second husband, Larry Klein, are exploratory to a marked degree. She moved to some extent in the direction of rock in *Wild Things Run Fast* (1982), and in *Dog Eat Dog* (1985) she exhibited a "synth-pop" idiom, which incorporates a more critical perspective on society. But as Miller notes in *Dictionary of Canadian Music*, with the album *Night Ride Home* (1991), Mitchell has come full circle to an artistic economy and introspection characteristic of her early, folk-based style.

In a particularly strong writing on Mitchell in his *Music: A Living Language*, Tom Manoff finds that her work, like that of Duke Ellington, transcends the limits imposed by the terms "popular" and "serious." Manoff remarks upon her synthesis of the arts, which is so conspicuous in her work as producer, composer, poet, and artist on most of her albums. As she remarked in a *Rolling Stone* interview in 1979,

> I wrote poetry and painted all my life. I always wanted to play music and dabbled with it, but I never thought of putting them all together. It wasn't until Bob Dylan began to write poetic songs that it occurred to me that you could actually *sing* those poems.

Regarding her striking departures from all norms in the 1980s, including her own neo-folk base, Mitchell observed,

> I know that some of these projects are eccentric. I know that there are parts that are experimental, and some of them are half-baked. I certainly have been pushing the limits and—even for myself—not all of my experiments are completely successful. But they lay the groundwork for further developments. Sooner or later some of these will come to fruition.

It is clear that Mitchell understood the experimental nature of her 1975 album *The Hissing of Summer Lawns*.

In 1976, she followed with the album *Hejira*, the title song of which is presented here. Manoff describes the album quite appropriately as a song cycle, unified by the theme that "time-honored notions of tradition have been lost to the siren song of change." The Arabic word *hejira* [flight] refers specifically to Mohammed's flight from religious persecution in Medina to refuge in Mecca. In the *Rolling Stone* interview, Mitchell recalls its genesis during a time of personal searching that speaks to many listeners:

> I was sitting out at the beach at Neil's place [Neil Young] and I was thinking, "I want to travel, I don't know where and I don't know who with." Two friends of mine came to the door and said, "We're driving across the country." I said, "I've been waiting for you; I'm *gone*." So we drove across the country, then we parted ways. It was my car. . . . *Hejira* was an obscure word, but it said *exactly* what I wanted. Running away, honorably.

Manoff finds the title song, "Hejira," one of Joni Mitchell's greatest song-poems. It recalls a piano setting by Schubert of a brook or a spinning wheel, whereby Mitchell suggests the whir of the modern age by an urgent continuum in the accompaniment, a nonidealized sound but a representative one. A stylistic unity is achieved here, superseding the experimentation of her previous albums. In this popular, modern song cycle Mitchell's folk-based singing and her song-speech are balanced, and an electronic, ultramodern production converges with acoustical sound.

Bibliography

Manoff, Tom. *Music: A Living Language*. New York: Norton, 1982. Pp: 428–36.

Miller, Mark. "Joni Mitchell," Entry in *Encyclopedia of Music in Canada*. 2nd ed. Toronto: University of Toronto Press, 1992.

Rolling Stone, 26 July 1979. Interview with Joni Mitchell. Quoted in Manoff.

Hejira

Words and music by Joni Mitchell

Moderately, in 2

with pedal throughout

I'm trav-'ling in some ve-hi-cle; I'm sit-ting in some ca-fé,
You know it nev-er has been eas-y, wheth-er you do or you do not re-sign,
Well, I looked at the gran-ite mark-ers, those trib-utes to fi-nal-i-ty, to e-ter-ni-ty.

And then I looked at my-self here: a de-fec-tor from the pet-ty wars
that shell shock love a-way, wheth-er you trav-el the breadth of ex-trem-i-ties
or stick to some straight-er line. chick-en scratch-ing for my im-mor-tal-i-ty.

198

Meredith Monk

(born 1942)

Meredith Monk was born in New York and spent her childhood there and in Connecticut. After earning a Bachelor of Arts in performing arts at Sarah Lawrence College in Bronxville, New York, she exhibited a strong interest in solo singing, film making, choreography, and directing. Her first theater piece, *Juice*, was premiered at the Guggenheim Museum in New York in 1969. The work is scored for 85 solo voices, 85 jew's harps, and two violins. Once a member of the young avant-garde, Monk has now become one of the most important creators of music theater and multimedia art.

Most of her compositions center around extended vocal techniques. According to the *Norton/Grove Dictionary of Women Composers*, her singing range of over four octaves includes "a variety of insistent, wistful, fey, or humorous cries (always wordless); at times Monk sounds as if she might be singing ethnic music from a culture she invented herself." Her eclectic style draws upon popular music, additive structures, and minimalism, and the music often is designed from melodic cells and a neo-modal melodic sense. However, Meredith Monk's music is far from simplistic, but instead exhibits a force that draws upon her sense of theater and the drama of mixed media.

In 1978 she shifted from her early 1970s emphasis on solo music to found the Meredith Monk Ensemble, which performed with her throughout the United States and Europe. The earlier, solo idiom may be represented by *Our Lady of Late* (1972–73), for voice and wine glass (in 1974 it was arranged for voice, glass, and percussion). Her expanded range of medium is seen in *Dolmen Music* (1979), for six voices, cello, and percussion; *Do You Be* (1987), for ten voices, synthesizer, two pianos, violin, and bagpipes; and *3 Heavens and 3 Hells* (1992), for four voices.

Monk's first feature-length film, *Book of Days*, was produced in 1988. *The Games*, a 1983 theater piece, a view of reconstruction after a nuclear holocaust, is scored for sixteen solo voices, synthesizer, electric keyboards, bagpipes, Flemish bagpipes, Chinese sheng (reed mouth organ), and Rauschpfeife.

Atlas (1991), an opera in three parts, is her longest and most substantial theater piece. It is scored for eighteen voices, two keyboards, clarinet, bass clarinet, sheng, medieval shawm, two violins, viola, two cellos, French horn, and percussion. According to the notes accompanying the CD recording, travel in *Atlas* is a metaphor for spiritual quest and commitment to inner vision. The opera centers on the life cycle of

one character, Alexandra Daniels. (Monk herself acted and sang this role in the premiere and the first recording). This character and the narrative are based on the writings of the explorer Alexandra David-Néel. In the opera, Alexandra Daniels and her travel companions embark on an expedition filled with adventures, encounters with spirits from other realms, and struggles with personal and societal demons. Guides initiate the travelers and finally conduct them to a realm of pure energy.

In Part I, "Personal Climate," the teen-age Alexandra is encouraged by her Spirit Guides to trust and follow her imagination. Time passes, and the adult Alexandra chooses companions to accompany her on her quest: Cheng Qing of Hunan, China, who aspires to "test courage," and Erik Magnussen, of Jörpeland, Norway, whose aspiration is "to see the world." In the scene at the airport, part of which is presented here, the three explorers celebrate the beginning of their journey.

In Part II, "Night Travel," the trio are joined by two others in the adventure to seek out the far corners of the Earth. Each traveler undergoes an ordeal on the trip, and although Erik Magnussen falls by the wayside, the victim "ensnared by his own desire made manifest in the militaristic, technocratic society run amok." However, the others attain a timeless, radiant place in Part III, "Invisible Light." Here, they come into spiritual knowledge. Alexandra, older and filled with wisdom, returns to Earth, sits at home, finally, drinking a cup of coffee and recalling her earliest memory, "the smell of morning coffee," and her aspiration, "to seek the unknown." She has realized that her search was for simple acts and the tenderness of moments, and the seeming expedition has become "the inner journey of a soul."

Atlas was premiered in 1991 by the Houston Grand Opera, following its renowned custom of producing a new opera nearly every season. Departing sharply from the tradition of opera with its collaboration of composer, librettist, producer, and so on, *Atlas* is properly understood as the complete conception of Meredith Monk. The composer's ideas in part derived from her experiences in 1985, when she produced *Dolmen Music* with the young singers of the Houston Opera Studio, a collaboration that led directly to the commission of *Atlas*.

As Max Loppert indicates in the liner notes of the CD, "Vocal and dramatic ideas, musical and movement motifs, were seeds already germinating in Meredith Monk's mind" beginning with the 1985 production and singer training she had coached in Houston. Improvisatory vocal techniques became "fixed" in her mind out of a stretching of material from the earlier work at Houston.

> Given the (by conventional operatic standards) loose-limbed way the whole work was put together, the remarkable thing about the narrative that underlies *Atlas* is its coherence, its built-in dramatic logic, and its sure control of dramatic momentum. . . . There is little verbal text in *Atlas*, in keeping with Monk's whole approach to verbal expressivity from her earliest days as a singer/composer. Most of the vocal lines are vocalise . . . in a dramatic context their variety and alternation . . . become a vocal equivalent of dance mime. . . . They can be charged with infinite subtle inflections for story telling. Much of the vocabulary of *Atlas* has been developed out of Monk's long absorption with unconventional voice-production techniques: ululation, cantilation, syllabic chanting, animal imitation, and other echoes of a generally non-Western kind. . . . In *Atlas* the familiar boundary lines of performance categories are dissolved. Monk's stated aim in tackling her Houston commission was an "attempt to re-define the idea of opera."

Monk's "Process Notes," which also accompany the CD, explain the genesis and concept-building that went into *Atlas*. Her vision of a multimedia form recalls that of the earliest creators who formulated opera, such as Monteverdi and Francesca Caccini:

> I've always believed that music theater, like film, in its integrative, inclusive nature can perfectly reflect the perceptual richness and complexity of our lives. Combining music (especially vocal music), movement and theater into a unified whole has been a major focus of my work over many years. Early on I called my works "opera," not in the sense of the European model that we usually think of, but rather as a description of the multi-perceptual, mosaic form that I was envisioning. . . . I began working on the music and concepts [of *Atlas*] in the summers of 1987 and 1988 at the MacDowell Colony. As is usual, my beginning process was intuitive. When shards of music suggested themselves to me, I developed them without knowing exactly where they would appear in the overall form. I composed most of the ethereal a capella choral music, which I called *The Ringing Place*. . . . Sections of this music form Part III, "Invisible Light." [Monk then recalls her work in 1989 with the costume and set designer Yoshio Yabara, the audition and training of singers in 1990, and the collaboration with musical director and conductor Wayne Hankin, who, like the singers, informed her generative process.]
>
> I've always resisted notating my music until I've performed it for quite a while and am satisfied with the form. For me, my music exists between the bar lines and beyond the notes. Nevertheless, I keep notebooks of ideas and themes. Occasionally I write out the complete forms before beginning rehearsal. For more complex vocal parts, I often use work tapes on which I perform all the parts myself so that I can recall the exact contrapuntal and textural ideas.
>
> In July 1990 we began a month-long preliminary workshop period with the singers. I taught those musical sections which were complete at the time. We also worked on theatrical improvisation based on the subject matter. . . . I asked the entire cast to learn all the vocal material without knowing who was going to sing what in the opera. . . . We tried to create a general atmosphere of play and exploration. . . . It was a joyful month. After our first rehearsal period, I revised and refined some of the original vocal material and wrote some new music with the particular qualities of each singer in mind.
>
> November 1990 saw the beginning of our second rehearsal period. . . . We also heard for the first time, with much excitement, the orchestrations set by Wayne Hankin. The instrumentalists offered wonderful suggestions of ways to approach playing the music. In January and February 1991, I put the scenes together in a final structure. It was at this time that *Atlas* unmistakably began to take on a life of its own. On February 22, 1991, we premiered *Atlas* at the Houston Grand Opera.
>
> When the time came to record *Atlas*, I had to rethink the overall form to let its energy speak entirely through the medium of sound. I was not trying simply to reproduce the live performance but rather to provide a new experience for the listener. I cut two scenes. . . . During the recording, Manfred Eicher and I tried to listen to the music as if we had never heard it before. Manfred offered invaluable suggestions about the instrumental timbres . . . and the singers and instrumentalists found fresh ways of working with the material. [Later] Manfred and I agreed that one further section should be cut: "Return to Earth and Conclusion," which was the last scene of the opera and one of my favorites. In the audio form, it became more of an epilogue . . .

and too much of a closure instead of letting the listener remain in motion at the end of the journey.

When I listen to *Atlas*, I am filled with memories of the process of making it. In many ways, *Atlas* has become a way of life. It has been an adventure for all of us, paralleling the adventures of Alexandra and her companions. *Atlas* would never have been the same without the generosity, creativity and spirit of all the performers, administrators, designers and technicians—fellow travelers on this expedition. My deepest thanks to all.

Discography

Atlas: An opera in Three Parts. ECM Records, CD 1491/92 437773–2. ECM Records, Postfach 600 331, 8000 München 60, Germany.

The score of *Atlas* is available from The House Foundation for the Arts—Meredith Monk, 131 Varick Street, Room 901, New York, New York 10013.

Airport, from Atlas

Meredith Monk

© 1991, Meredith Monk. All rights reserved. Reprinted by permission.

m. 5

m. 13

m. 17

m. 21

m. 24

m. 27

like a telegraph:

m. 32

m. 34

m. 36

m. 38

m. 40

220

Undine Smith Moore

(1905–1989)

Undine Smith Moore was born in Jarratt, Virginia, and died in Petersburg, Virginia. At Fisk University in Nashville, Tennessee, she studied piano and organ with Alice M. Grass and earned the Bachelor of Arts and Bachelor of Music degrees. Moore continued her education at the Juilliard, Manhattan, and Eastman schools and at Columbia University Teachers College. She was awarded honorary doctorates by Fisk University and Indiana University.

Her teaching career began in the public schools of Goldsboro, North Carolina. Her primary position, however, was at Virginia State College in Petersburg, where she taught from 1927 until her retirement in 1972. There she co-founded the Black Music Center (1969–72) and taught such outstanding musicians as Billy Taylor, Camilla Williams, and Leon Thompson. She appeared as guest lecturer and professor at Virginia Union University, the College of St. Benedict, St. John's College, and Carlton College.

Undine Smith Moore's instrumental compositions and later vocal music included strong dissonance and occasional atonality. Among her important works are *Introduction, March and Allegro* (1958), for clarinet and piano; *Afro-American Suite* (1969), for two flutes, cello, and piano; organ variations on "Nettleton" (1976); and the piano trio *Soweto* (1986). The numerous vocal compositions of her early years are clearly tonal, most often expressing a passion for the traditional African American idioms of the spiritual and the gospel song. She wrote two extended cantatas—*Sir Olaf and the Erl King's Daughter* (1925) and *Glory to God* (1974)— but her masterpiece is probably the oratorio *Scenes from the Life of a Martyr* (1982), based on the life of Martin Luther King, Jr. Her single-movement choral works include "Thou hast made us for Thyself" (1952), "When Susanna Jones wears red" (c.1958), "O Spirit who dost prefer before all temples" (1966), and "Tambourines to glory" (1973).

Some of Moore's many songs for solo voice and piano or organ are in a stylistically direct, tonal idiom and relate to the black tradition, for example, "Set down!" (1951), "To be baptized" (1973), and "Watch and pray" (1973). A number of her works go outside the parameters suggested by black idioms, such as the solo songs with piano "Love, let the wind cry how I adore thee" (1961) and "Lyric for true love" (1975), and the SSA chorus "Teach me to hear mermaids singing" (1953).

Likewise, the composition included here, *Mother to Son* (1955), synthesizes elements of the blues (mm. 1ff.) and the spiritual (mm. 5ff. in the chorus). Contempo-

rary idioms of extended tonality and parallel chord progressions (m. 12) are also heard. The passages of extended chromaticism (mm. 15–20) show Moore's technique for suspending tonality for expressive purposes. Note also the cantata-like contrasts of textures and performing resources in this work, which is scored for alto solo, trio of women's voices, and SATB chorus in varying textural combinations.

In *The Black Composer Speaks*, Undine Smith Moore asserts that "I most prefer writing for unaccompanied mixed chorus." Asked what she considered her most significant compositions, she singled out the third movement of the *Afro-American Suite*, for alto flute, cello, and piano. She added, "I think that *Mother to Son* (on poetry by Langston Hughes) is fine in its use of vocal tone color and in the general writing." She spoke of her pride in the choral arrangements *Daniel, Daniel Servant of the Lord* and *Lord, We Give Thanks to Thee*—a genre more creative by far than the term "arrangement" suggests, she argued. Asked what she would compose if she were provided with unlimited resources of money and opportunity, she responded, "I would wish to write . . . for the performance possibilities of the thousands of performers and groups for whom there must be a continuing repertoire. The masses of amateur choirs, school groups, church groups, etc., deserve a less banal repertoire of choices."

Undine Smith Moore left an invaluable record of her perspectives in *The Black Composer Speaks*, responding to a questionnaire from the editors. Topics range from personal development to her status as a black composer, and from issues surrounding modern composers to those of mixing teaching with composing in her career. Her parents were decisive personalities in her life: "I realize how deeply touched I was by the spirituals sung by my mother and father—how much the spirituals sung at Fisk were part of me." She remarked that "I have read all my life," and recalled her mother's taste for reading, "which made me a child always afraid of being caught somewhere without a book." She cited as important her college experiences of reading the poets of the Harlem Renaissance, particularly Langston Hughes. In a difficult time during adolescence, "I practically made it from day to day by reading the Stoic philosophers, especially Epictetus."

She also valued the model of her teachers, especially Lillian Allen Darden and Alice M. Grass at Fisk, and Howard Murphy, who taught theory and composition at Columbia. She called attention to the scholarly and liberal personality of her husband, James Arthur Moore, who permitted her "a freedom denied many wives of my generation"; and she identifies as a personal inspiration "the *self*" of her daughter, Mary Moore Easter, her pride and joy.

Moore counted among her formative influences her visit to West Africa, to the slave-trading centers of Gorée in Sénégal and El Mina in Ghana, where she learned much from observing "ordinary people of the area going about daily tasks." She also found rich experiences in the sculpture, ceremonial masks, and jewelry of West Africa, but also in Van Gogh's *Self-Portrait*—"the essence of human pain and the reminder of my brother's personal tragedy"—and in Monet's *Water Lilies* in Paris.

In later years her thinking was marked by readings of *The Narrative of Frederick Douglas*, Benjamin Quarles's *The Negro American*, and works by Ralph Ellison, Toni Morrison, Paul Tillich, and "above all, now, the poets Alice Walker, Anne Sexton, Margaret Walker, Gwendolyn Brooks, Yeats, and older poets I have loved for years."

On the role of the black artist in society, Moore said, "Without positing a social purpose as a requirement for art, [the artist] *really* cannot escape expressing his heri-

tage somewhere in the body of his work. This expression . . . is a powerful agent for social change." She cited Picasso's *Guernica* as a social agent, and also spoke of the contralto Marian Anderson,

> by the power of her art . . . opening the doors of Constitution Hall to black artists. Paul Robeson's career cannot fail to have contributed to change in the channels of social philosophy . . . or André Watts, by the sheer perfection of his playing [he became] an agent of social change.

Moore decried the limitations on young black persons when they face reduced expectations.

> [As a youth] I had no early contact with anyone who had ever published anything—or who knew anything about getting anything published. . . . I drifted into what I *could* call a composer in my own language, by writing music to meet the demands of the situations in which I worked . . . for a high school [where she first taught in rural Virginia] with a total population of 80 pupils, I edited the Gilbert and Sullivan operettas, one a year.

In addition to her composing, Moore found her teaching "a tremendously important activity in my life." She identified many eminent pupils, who now occupy positions at national levels in the music profession. But, "There are many students who have no national standing whose work I respect as highly, for they are raising the level of appreciation and musical understanding in small communities." As composer and teacher, she worked hard to address a spectrum of audiences, from clinics for high school teachers to professorships at major universities and a Town Hall performance. "Performance opportunities [ought to be] available to all at an early age." Music by black composers "should be taught as a part of music study where it is appropriate." On the singling out of black composers for emphasis, "For a while, it may be necessary to compensate for the neglect of the past by separate courses."

Undine Smith Moore was asked, finally, whether she would have chosen to devote herself to composition on a full-time basis, given the chance:

> Trying to teach what I can about the great art of music, to stimulate students to realize what potentialities they have (which they often do not realize), and what opportunities are now open to them is extremely satisfying to me. I experience teaching itself as an art, and have found it to have a valuable reciprocal relation to the art of composition. As long as I am able, I would like to do both. It would be fine to have a life so ordered that everyday responsibilities did not impinge so heavily on my time. . . . This question was surely written for men. Their wives assume those dreary responsibilities which make it possible for them to compose.

Bibliography

Baker, David; Lida M. Belt; and Herman C. Hudson, eds. *The Black Composer Speaks*. Metuchen, New Jersey: Scarecrow Press, 1978. Pp. 173–202.

Mother to Son

Text by Langston Hughes.
Copyright 1932 by Alfred A. Knopf, Inc.

Undine Smith Moore

© MCMLV by M. Witmark & Sons.

228

Alice Parker

(born 1925)

Alice Parker was born in Boston. She received her Bachelor of Arts from Smith College in Northampton, Massachusetts, in 1947, and later the Smith Medal for "filling countless lives with song." She earned a Master of Science at the Juilliard School of Music in 1949. Parker established a distinctive career line as principal arranger for the Robert Shaw Chorale, working in that capacity from 1948 to 1967 and publishing more than 400 arrangements of folk songs, hymns, and carols.

From 1965 to the present, Parker has devoted increased energy to the other direction that makes her a major force in contemporary music: original composition. Her works include four operas, 25 cantatas, and numerous chamber works both vocal and instrumental. She is in great demand as clinician, conductor, and teacher of choral ensembles. Few composers and arrangers have matched the breadth of her popularity or the widespread appreciation within the area to which she has given herself. In the concert season 1995–96 alone, her performance schedule, conducting her original compositions and arrangements, took her to cities in the United States, Canada, Venezuela, and Argentina.

Alice Parker has received three honorary doctorates and yearly composer awards from ASCAP (American Society of Composers, Authors, and Publishers) since 1968, as well as grants from the National Endowment for the Arts and the American Music Center. Recent commissions have come from the Barlow Endowment and from the Vancouver Chamber Singers for *That Study Vine* of 1992. Parker received the Matrix-Midland Award for Excellence in Music for *The World's One Song* in 1989. In 1994 *Chorus America* named her the recipient of the Michael Korn Founders' Award, in recognition of her service to choral music in the United States. Also in 1994 she was featured at the First Hungarian-American Conference on Sacred Music, which was held in Budapest.

For many years Parker has offered the course "Writing for Voices" at Westminster Choir College in Princeton, New Jersey, one of the most distinguished teaching institutions in the world for choral music. The course is "open to anyone with a continuous love for singing." In 1984 she founded the sixteen-voice chamber ensemble Melodious Accord, Inc., and currently is its Artistic Director, presiding over a full schedule of concerts, recordings, and educational activities. She entered the field of innova-

tive media production in 1995 with the videotapes *When we sing* and *The reason why I sing*, and that year she also supervised a recording of African American spirituals.

Parker has resided in New York City since her Juilliard days. She was married to the respected choral contractor Thomas Pyle, who died in 1975. As she recalls in a 1995 feature article in the *New York Times*, "I spent the next ten years getting our five kids through college, and constantly traveling. . . . Tom's death made me focus on my work." The author of the article, Leslie Kandell, finds that "after years as a supporting player, [Parker] has come into her own." Kandell observes a particular originality, in no way to be undervalued, in Parker's choral arrangements. They have a "spare, modal style with imitative lines that is quickly recognizable" and "the twang of the shape-note and Shaker eras, completely opposite to the Romantic lushness of arrangements by Stokowski." Parker claims that "my main purpose [in the arrangements] has to do with exploring melody divorced from harmony or accompaniment, so inflection of melodic line is primary—100 percent." Kandell calls Parker's translations of the acknowledged masterpieces "immaculate" and cites a line from Haydn's *The Creation*: "'and to the ethereal vaults resound,' [which] becomes for Parker 'and loud resound throughout the skies,' so the grateful singers can open their mouths wide."

In a personal communication Parker writes

> I remember being very clear at age eight that I was a composer. No immediate role models—just all the great ones of the past, and no feeling of being excluded because I was a woman. . . . I had sung since my earliest childhood with a mother who had longed for music lessons but never got them. At Smith I loved my composition teacher, Werner Josten, but hated the twelve-tone techniques he was trying to instill in me—it ended up with my not writing anything original for fifteen years. By the time I was old enough, finally, to realize that no one could tell me what or how to write, I was free to follow my own path.
>
> I don't see any difference between the "modern" artist and those of past generations. There are a lot of distractions now: the whole publicity machine, and "success" being defined in terms of either academic or "popular" styles. But the basic challenge is the same as for Bach or Mozart: can I develop my own skills so that my ideas are realized without too much dilution, and can I serve my immediate community by my gifts. In other words, I must be a performer as well as a composer, and earn my living by writing music that people want to perform and listen to.

When asked how she would wish to be recalled by future generations, Alice Parker responded succinctly, "as a craftsman, one who understands the voice and the setting of words, and who brings pleasure to players and listeners."

The genesis of *Songstream* (1986), the set represented here by the component chorus "Lethe," stems from a commission by the Hampshire Choral Society in Northampton, Massachusetts. All of Parker's works are commissioned: "I want to know who, when, where, and why a piece will be performed before I start to write." She found in the poetry of Edna St. Vincent Millay

> texts roughly analogous to Brahms's *Liebeslieder*—rather light love songs. . . . I'm very fond of *Songstream*. The poems are wonderful, and I think I succeeded in capturing that mix of sentiment and tongue-in-cheek American slang (irony?) which is in her work. I also enjoyed Brahms's presence—the melodic emphasis, the dance, and the harmonies—it's really much more harmonically (tonally) centered than my other original pieces.

Bibliography

Kandell, Leslie. "Loving the Product, Preferring the Process." *The New York Times*, 2 July 1995.

Lethe, from Songstream

Alice Parker

233

235

Dolly Parton

(born 1946)

Since her early childhood in the Appalachian foothills of Locust Ridge, Tennessee, Dolly [Rebecca] Parton has "invented songs." Her mother recorded the early song texts, before the child could write, and Dolly Parton and her siblings were actively encouraged to cultivate their talents. The fourth of twelve children in a farm family, and the granddaughter of a preacher, Parton first sang at the Grand Ole Opry in Nashville at the age of twelve. According to Pamela Wilson, "Songs, like stories, have been a vital part of the cultural economy of Appalachian women: producing songs, like producing children, has been important to their social identities."

After she graduated from high school, Dolly Parton moved to Nashville to live with an aunt and uncle and to pursue her career in country music. Still retaining close family ties, in 1974 she led a tour with her own Travelin' Family Band, which included brothers, sisters, an uncle, and a cousin.

Her early appearances in Nashville, especially those with Porter Wagoner's band and as partner on his television show, tended to type-cast her—indeed, her first recorded hit was "Dumb Blond," in 1967. However, she manipulated even that image into a recording contract with RCA, and soon popularized her songs "Joshua," " Jolene," "In My Tennessee Mountain Home," and the example presented here, "Coat of Many Colors." Her early voice type was high soprano, but in her duo work with Porter Wagoner, her vocal quality matured and she achieved versatility of range and color.

In an ironic manipulation of her visual style—the stereotypical display of the "painted women"—Parton has articulated an image as a smart, wholesome, and sincere person with traditional rural values. As Pamela Wilson notes, she thus has managed, through perseverance and resourcefulness,

> to transcend the disadvantaged economic and social circumstances into which she was born and to use her talents to realize many of her dreams. And yet, through the construction of her persona, Parton manages and actively exploits the contradictory meanings associated with the social categories of gender, class, ethnic, and regional identity. Parton is often compared to Mae West, Marilyn Monroe, Bette Midler, and Madonna for her manipulation and burlesquing of femininity.

Dolly Parton is completely aware of her persona construction and does not wish to be entangled or limited by it:

> I'm careful never to get caught up in the Dolly image, other than to develop and protect it, because if you start believing the public persona is you, you get frustrated and mixed up.... I see Dolly as a cartoon: she's fat, wears a wig, and so on.... Dolly's as big a joke to me as she is to others.

Her calculated image and humor nonetheless were the main reasons fans initially took an interest in her: "You'd be amazed at how expensive it is to make a wig look this cheap." But certain elements are native to her: "I always liked the looks of our hookers back home. Their big hairdos and makeup made them look *more*. When people say that less is more, I say *more* is more. Less is *less*; I go for more."

Dolly Parton was chosen Best Female Vocalist by the Country Music Association in 1975 and 1976. She made numerous appearances on television shows hosted by Merv Griffin and Johnny Carson and on "Hee-Haw." In 1976–77 she had her own television show, "Dolly," the first country music show hosted by a woman. In 1977 she toured the United States and Europe with a new group of her own, Gypsy Fever, and with it turned to mainstream popular rock. In all, her repertory ranges from Appalachian ballads to African American gospel to a forceful rockabilly style. She received Grammy Awards in 1978, 1981, and 1982.

In the 1980s Parton began acting in movies, starring in *Nine to Five* with Lily Tomlin and Jane Fonda, *Best Little Whorehouse in Texas* with Burt Reynolds, *Rhinestone* with Sylvester Stallone (for which she wrote no fewer than twenty songs), and *Steel Magnolias* with Sally Field and Shirley MacLaine.

Dolly Parton is open and proud when she discusses the working-class values of her husband, a paving contractor. As Pamela Wilson quotes her,

> He's really bright. He's not backward at all. I just wish that people would let him be. He's a home-lovin' person.... He wouldn't have to work no more, because I'm making good money now, but he gets up every morning at daylight.... He'll say, "Well, I ain't in show business, I got to work."

Parton, a foremost writer of country music, has composed most of the songs that made her famous as a singer. Much of their subject matter derives from her childhood experiences. "Coat of Many Colors" (1969) recalls a coat her mother made for her by piecing remnants together.

Parton salutes females of strength repeatedly. About her song "Eagle when she flies," she says, "I wrote about my mother, and about myself—about Mother Teresa, Amelia Earhart, Harriet Tubman, Eleanor Roosevelt.... I hope maybe you guys will appreciate this too." In a 1978 *Playboy* interview she was asked,

> "Do you support the Equal Rights Amendment?"
>
> "Equal rights? I love everybody...."
>
> "Do you read any books on the women's movement?"
>
> "Never have. I know so little about it they'd probably be ashamed that I was a woman. Everybody should be free: if you don't want to stay home, get out and do somethin'; if you want to stay home, stay home and be happy."

Pamela Wilson quotes Linda Ronstadt, an occasional collaborator with Dolly Parton, who summarizes Parton's gift succinctly:

> I think Dolly is a girl who was born with an amazing amount of insight into people.

It's like an intelligence of compassion. Shakespeare really understood human behavior. Tolstoy could write the greatest novel ever because he really understood what makes people tick. And I think Dolly Parton is one of those kinds of people. She has that kind of intelligence; she is amazingly perceptive.

Bibliography

Flippo, Chet. "Dolly Parton: Tennessee Mountain Home-Grown." *Rolling Stone* 198 (23 October 1975):24.

Gammond, Peter. *The Oxford Companion to Popular Music.* Oxford and New York: Oxford University Press, 1991.

Parton, Dolly. Interview in *Playboy* 25/10 (October 1978): 81–84, 88–91, 95–98, 101–10.

Wilson, Pamela. "Mountains of Contradictions: Gender, Class, and Region in the Star Image of Dolly Parton." *The South Atlantic Quarterly* 94/1 (Winter 1995):109–34.

Words and music by Dolly Parton

Moderate

1. Back through the years I go wan-d'ring once a-gain
back to the sea-sons of my youth.
I re-call a box of rags that some-one gave us and

how my ma-ma put the rags to use. There were

2. rags of man-y col-ors but ev-'ry piece was
3. sewed she told a sto-ry Bi-ble she had
4. patch-es on my britch-es holes in both my
5. could-n't un-der-stand it for I felt I was

small and I did-n't have a man-y coat of col-ors
read, and I told of man-y coat of col-ors
shoes, and I told 'em of the love
rich.

('way down in the fall. Ma-ma sewed the rags to-
wore and she said to per-haps I'll find this coat of
hur-ried off to school just to find them all
sewed in ev-'ry stitch and I told them all the

gether sewing ev'ry piece with love. She

and it was Jo-seph
my ma-ma

Marta Ptaszyńska

(born 1942)

Marta Ptaszyńska was born in Warsaw during the turbulence of World War II. She studied composition at the Warsaw Music Academy with Tadeusz Paciorkiewicz and percussion with Mikolaj Stasiniewicz. In the early 1960s the percussion work *Four Preludes for Vibraphone and Piano* attracted the attention of the renowned composer Grazyna Bacewicz, who strongly encouraged Ptaszyńska to emphasize composition. In 1968 she earned three master's degrees with distinction—in composition, music theory, and percussion. During that period she worked independently with Witold Lutoslawski, who became her mentor. With a French Government grant to Paris for the period 1969–70, she studied composition with Nadia Boulanger, analysis with Olivier Messiaen at the Conservatoire, and electronic music techniques at the French Radio. In 1974 she earned an Artist Diploma in percussion at the Cleveland Institute, having received grants from the Institute and the Kosciuszko Foundation in New York; in Cleveland she studied percussion with Cloyd Duff and Richard Weiner, and composition with Donald Erb.

Since 1972 Ptaszyńska has resided in the United States. In 1974 she married a fellow Pole, an engineer, and she now lives in Pennsylvania. She is musically active in many places and roles, commuting often and easily between Europe and the United States for concerts, lecture appearances, and performances as a percussion virtuoso. As Jolanda Rostwarowska quotes her in *PolAmerica*, "Warsaw is a very inspiring city for creative work, especially in autumn during the International Festival of Contemporary Music, 'Warsaw Autumn,' which has been held for thirty years." Ptaszyńska spends every summer and early autumn there.

After 1970 Ptaszyńska taught theory and percussion at the State College and Higher School of Music in Warsaw, and thereafter composition and percussion at Bennington College in Vermont. She also has taught at the University of California at Berkeley and at Santa Barbara, and at Indiana University. She has presented many master classes, concerts, and clinics at universities and schools of music throughout the United States, including Eastman, Manhattan, Northwestern, Cincinnati, the University of Illinois, and San Francisco State University. As a percussionist Marta Ptaszyńska has performed extensively at major festivals in Europe and the United States and has premiered many percussion works. In 1986 she co-founded the International Percussion workshops in Bydgoszcs, Poland, and co-founded the American Society of Polish Music in New York.

Her *Winter's Tale* for string orchestra received the second prize in 1986 at the International Rostrum of Composers of UNESCO. Ptaszyńska received a medal from the Union of Polish Composers and an award from Polish Radio and Television for her opera *Oscar of Alva*, to the Lord Byron poem. Three compositions for percussion received prizes from the Percussive Arts Society in the United States—*Siderals* (in 1974), *Classical Variations* (in 1976), and the *Concerto for Marimba and Orchestra* (in 1987), and the marimba concerto was premiered at the International Convention of Percussionists in Washington, D.C. Yehudi Menuhin conducted Ptaszyńska's *Holocaust Memorial Cantata* on several occasions in 1993 to critical acclaim. Many international festivals have featured her compositions, including the ISCM World Music Days, the Warsaw Autumn, the Schleswig-Holstein Music Festival, and the Aspen Festival. Her music has been premiered by renowned artist-conductors and foremost symphony orchestras, such as those of Cincinnati, Cleveland, Kraków, Varsovia, Strasbourg, and the Polish Chamber Orchestra.

In a private communication, Marta Ptaszyńska describes her development as a woman composer:

> From the time I was accepted as a composition student at my school, I was trained to be a professional composer. . . . While in Poland, there was no distinction between composers, since I was taught that creativity is not a matter of sex, but a matter of a strong and disciplined mind, imagination, knowledge, and "God's gift.". . . So I didn't even realize the existence of such a division as "male and female" composers until I came to the U.S., where I was soon told about it. . . . Always what I experience is the difference between poorly written and excellently composed works. This is the only division for me that matters. I tried a test on my students, and no one could guess whether a male or female composer was in question. But when I played poor-sounding music, written by women as well as men, many students indicated women as the authors. This experiment showed me that the problem is more social than truly artistic.

Writing in *Studio* magazine in 1994, Tadeusz Zielinski relates the music of Marta Ptaszyńska to that by her compatriots Chopin, Szymanowski, and Lutoslawski, all of whom share the traits of a colorful and sensual stratum of sounds and a marked lyricism. Accordingly, modernism and tradition are not opposites, but are fused. In her music Ptaszyńska is devoted to the esthetic of innovative sound resources, especially involving acoustical instruments, a tendency related to "sonorism," which is prevalent in recent Polish music. Nonetheless she does not relinquish the Polish affinity for melody, but draws inspiration from varied sources, including contemporary issues and the related arts. The Surrealist painters Max Ernst, Joán Miró, and Yves Tanguy have figured prominently in her thought, and she has named movements and works after their paintings, specifically, the three movements of the Marimba Concerto. Her *Moon Flowers*, for cello and piano, takes its name from the painting by the Symbolist Odilon Redon; and *Mobile*, for two percussionists, was inspired by Alexander Calder's mobiles. "These are my individual musical visions derived from viewing these [art works]." Her other fascination is Asian art, music, and philosophy. "I do not apply the Eastern static element in a naively literal sense. Despite the slow motion, there must be constant action and development."

> In my music, I understand that novelty is not a basic principle of a piece. The new sounds and compositional devices must be subordinated to an overall superior musi-

cal thought. What is most important for me in musical composition is the deep esthetic experience, and then the technical realization of that content. . . . I am equally interested in the structures of chords in various arrangements of the twelve tones, and in the harmonic consequences derived from a particular arrangement of that scale. For each composition I create a separate harmonic construction . . . selecting the scale and chord structures and the "appropriate" harmonic progressions. . . . The overall form of each composition is worked out in its general outline from the very outset. [Structure for me] is usually quite simple and clear, often exploring the traditional forms in new ways, such as rondo in *Winter's Tale*, quasi sonata-allegro or theme and variations in the *Marimba Concerto*, and ABA or arch forms in many chamber and solo works.

The *Marimba Concerto*, composed in 1984–85 for its January 1986 premier,

was inspired by my fascination with Far Eastern philosophy and culture, and by my strong feeling for Surrealist painting. Being a percussionist, I knew how much need there was for a contemporary marimba repertory. Until recently percussionists, including myself, had to play all kinds of transcriptions from the piano and violin literature. My goal was to write a large-scale concerto with the scope of the big piano concertos, with a virtuoso-like treatment of the marimba. No wonder that so many marimbists are performing this work and, even more important, they enjoy performing it.

Bibliography

Ptaszyńska, Marta. Autobiography dated May 1995, provided by the composer.
Rostwarowska, Jolanta. "Marta Ptaszyńska—Polish Composer." *PolAmerica* (Los Angeles), Spring–Summer 1988, pp. 10–13.
Smolenska-Zielinska, Barbara. Trans. Przemyslaw Znaniecki. "Focus on Research: Concerto for Marimba by Marta Ptaszyńska." *Percussive Notes* 29/4 (April 1991):78–82.
Zielinski, Tadeusz Andrzej. "Poetry of Sounds and Moods." *Studio* (Warsaw) 6/14 (June 1994):27–29. In Polish.

Discography

"Concerto for Marimba and Orchestra." On the recording *Marta Ptaszyńska*. Polish Radio Recordings–Polskie Nagrania. Keiko Abe, marimba; Kraków Symphony Orchestra; Szymon Kawalla, conductor. Recorded 1986, released 1991. CD PNCD 075.

Thorn Trees, from Concerto for Marimba and Orchestra

Marta Ptaszyńska

TEMA

Allegro molto leggiero e staccatissimo (♪=160)

VAR. I
Allegretto gioioso

attacca

VAR. II

Vivo, molto leggiero (♪=180)

attacca

VAR. III

Allegro gioioso

VAR. IV

*utrzymać tę samą pulsację, od początku do końca wariacji
keep the same pulsation, from the beginnig until the end of variation

249

VAR. V

Allegro maestoso (\quarternote=100)

251

VAR. VI

Allegro moderato, molto leggierissimo

attacca

VAR. VII

Vivo e molto energico

A L'istesso tempo

255

256

Shulamit Ran

(born 1949)

A native of Tel-Aviv, Shulamit Ran began her studies of composition with Alexander Uriah Boskovich and Paul Ben Haim, at the same time pursuing piano with Miriam Boskovich and Emma Gorochov. Her parents had emigrated from prewar Germany and Lithuania to British Palestine, which became the modern Israel. In 1963 she came to the United States, accompanied by her mother, to attend Mannes College of Music, on a scholarship from the America-Israel Cultural Foundation. Her father joined them when the scholarship was renewed, although it meant starting anew in his business. At Mannes she studied composition with Norman Dello Joio and piano with Nadia Reisenberg, graduating from Mannes and high school nearly simultaneously in 1967. She continued piano study with Dorothy Taubman and composition with Ralph Shapey.

At the age of fourteen, Shulamit Ran performed her *Capriccio* with the New York Philharmonic and Leonard Bernstein at a Young People's Concert, and she performed widely in the United States and Europe from 1968 to 1973. In 1974, just before her 24th birthday, she joined the faculty of the University of Chicago, where she remains as of this writing. She has served as visiting professor at Princeton University and, before moving to Chicago, at St. Mary's University in Halifax, Nova Scotia. She ceased performing in 1973 to concentrate on composing. In 1986 she married Abraham Lotan, an otolaryngologist and surgeon for the head and neck. "He's the smile on my face," says Ran, as quoted by C.B. White. Lotan and Ran have two sons.

Ran received Guggenheim Fellowships in 1977 and 1990, grants from the Fromm Foundation (for *Ensemble for Seventeen*), the National Endowment for the Arts (for *Piano Concerto*), and the Da Capo Chamber Players (for *Private Game*). She was appointed composer-in-residence of the Chicago Symphony in 1990. Major premieres and performances include those of her *Concert Piece* (1971), with the Israel Philharmonic conducted by Zubin Mehta (with Ran as piano soloist); *Hyperbolae*, as the required work in 1977 for the Second Annual Artur Rubinstein International Piano Competition; the String Quartet No. 2, *Vistas*, for the Taneyev String Quartet performance in Leningrad in 1989; and the work presented here, *Symphony*, in 1990 by the Philadelphia Orchestra. Shulamit Ran won the Pulitzer Prize in 1991 for *Symphony*—she was the second woman to do so—and the work also received the 1992 Kennedy Friedheim Award. (Ellen Taafe Zwilich had received the Pulitzer Prize for her *Symphony No. 1* in 1983.)

Ran has received a commission from the Lyric Opera of Chicago for a new work to be premiered in 1997. It is based on Shloime Ansky's 1916 play of *Dybbuk* [Evil Spirit], a staple in the Yiddish theater, in which a young girl is possessed by the soul of her dear beloved.

> Every time that I read it, there is a point that I start crying. It is so incredibly passionate and mysterious, and ecstatic, and all the things I'd like music to have. Very, very special. It won't be simple. One has to distill all that happens in the play, and yet keep the essence powerfully present.

In an interview with C.B. White, Shulamit Ran recalls that her parents encouraged her to "reach for the sky." "The strongest thing that I ever had going for me was the incredible support and commitment of my parents. They have always been like rocks in my life." From earliest childhood she remembers imagining melodies to accompany anything that rhymed. Her first composition to be performed publicly was a setting of Israeli poetry, sung by a children's choir over Israeli Radio. "Without telling her," White reports, "her first piano teacher had submitted the songs. Ran heard the performance on the radio at summer camp and was hooked on composing."

Ran has had to compartmentalize her time and efforts:

> When I am at the University . . . I am involving all my mental and emotional capacities 100 percent in the task of teaching. Then I go to the Chicago Symphony, and I put another hat on. . . . The more of a complete and total job I do with the time I do it, the more I can then move to the next thing and give *it* all I've got. . . .

> [My children] are absolutely first. Their presence is always with me, no matter what I do. When I hug the baby or hold the three-year-old, I force myself not to be thinking at the same time about the next task. . . . It takes a great deal of mental discipline, but it's the only thing that seems to work.

As one might predict, most of her concentrated composition occurs in the summers.

Analogously, Shulamit Ran aims for just such an economy and equilibrium in her music. In a *New York Times* interview with Allan Kozin, she said, "I want my music to challenge both the mind and the heart, and to do so in equal fashion." Writing in the same newspaper, critic Edward Rothstein notes that "Ran tends to use repeating thematic fragments in different contexts; it is as if the same material were being viewed through different emotional filters rather than being constantly transformed by reflection and experience." As C.B. White quotes her,

> The challenge is to take one idea and then really work with it and employ everything that I have by way of imagination and inventiveness to take it as far as I can take it. In any creative act, there needs to be a fine balance between the element of the intuitive—the fantasy—which is really subconscious, with discipline, which is to a large extent a conscious thing. . . . I find myself always engaged in a search, trying to tune in to what needs to happen next, where the music wants to go—as though trying to probe its deep secrets. It is as though to every phrase I compose there are powerful consequences as to what is to happen next.

Ran has found being a woman composer no more difficult than being a contemporary composer in general.

> I generally do not talk to my women students about being women in the profession. But if they raise the question, the point I try to get across is, "What does that have to

do with composing music? Would you talk about Beethoven as a *man* composer? . . . Just go do it . . . and [quoting her parents] "reach for the sky."

In the questionnaire responses published by Elaine Barkin in *Perspectives of New Music*, Ran likewise says that "it is how we feel about ourselves that really counts. [Being a woman composer] has never been an issue for me . . . being a woman has not been a hindrance." She adds quickly that

> new music, we all know, is facing immense problems, regardless of the sex of its creator. I find myself reacting with much greater vengeance about this issue than about the woman composers issue.
>
> Does it follow, then, that I am indifferent to concerts, symposia, congresses, recordings, publications, which feature exclusively the work of women? This is where the question becomes more complicated. From a purist's point of view, the answer is yes. In an ideal world, the only criterion for being included on a program of any kind should be the quality of the music. . . . In addition to which, after all these years of forced discrimination, would we [as women composers] choose to call attention to ourselves as a "ghetto"? But I see another side, too, and its logic is also compelling. . . . The central issue, in my view, is that of self-image. . . . We must educate, provide encouragement and information, lend support and see to it that all women know that the sky is the limit, not past prejudices. It is here that special programs structured to highlight women's growing contribution to composition today, as well as provide an understanding of the historical conditions that prevented women from achieving their full potential in the past, can be of considerable value.

Ran wrote the following program note for the 1990 premiere of *Symphony* by the Philadelphia Orchestra:

> As is the case with many of my works, but especially those of the last dozen years or so, most of the important ideas of the entire *Symphony* are clustered together early on in the first movement and are organically related. The spacious horn solo at the opening is the first major theme. Aspects of this theme are taken up in various guises at other important points. The leisurely dotted rhythm is taken up again in the slow, high violin melody (m. 19), which later becomes Movement II's principal theme. A brief, slow, majestic woodwind and brass chorale (m. 24) is set to act as would-be consequent to the aforementioned high violin melody. . . . Finally, the interval of the third with which the opening melody is replete is probably the most characteristic foreground-level building block of the entire symphony.
>
> Connections between movements abound. It is as though ideas appearing early on and having one kind of function are given new identity, taking on a new life as the work progresses. The slow, high violin melody, which appears only once in its simple, original form in the first movement—suspending the previous intense motion while, at the same time, providing an antecedent to the woodwind/brass chorale—opens the second movement and is now much elaborated. The new development leads to a modified version of the theme (viola, m. 62), which is treated in a quasi-fugal manner, eventually reaching its climax in a loosely structured mensuration canon in three voices (m. 102). The other important element of the second movement is a muted trumpet idea which originated in the first movement (upbeat of m. 52), returning unaltered at first, but with further elaborations as the second movement unfolds.
>
> . . . Eventually, the transformation of materials reaches full circle, as earlier ideas are brought back in the symphony's final, climactic moments. Most prominent among

these are the percussion cadenza recalling parts of the first movement, the chorale/ostinato, and, finally, the opening melody now heard on all six horns as the dominant component of a much richer texture.

In recent years, I find myself progressively more drawn by the idea, and the ramifications, of a formal return in a piece of music yet, at the same time, moving onward. As in life, one can never go back in time. There is no such thing as a real recapitulation. What has happened in the intervening time has altered things irrevocably. Pitted against this reality is an equally compelling statement, namely, the more things change, the more they remain the same. The cyclical versus the inevitability of the flow of time are two major currents at the source of all of life and nature. Music, I believe, has the unique power to reconcile and be expressive of both.

My first symphony is dedicated to Ralph Shapey, my great colleague, friend, teacher.

Bibliography

Barkin, Elaine, compiler. "In Response" (a questionnaire to women composers). *Perspectives of New Music* 20/1–2 (1982–83):311.

White, C.B. "Equilibria: Shulamit Ran Balances." *ILWC Journal*, October 1994, pp. 1–4.

Symphony, Movement II

Shulamit Ran

Copyright Theodore Presser, Co., 1992. Reprinted by permission of the publisher.

265

N.B. Start at any point, do not coordinate with others, —— may be added to figure.

271

275

PERFORMANCE NOTES

1) Accidentals apply to following note only, except in the case of consecutive repetition, or when part of a trill type figure, e.g., where the accidental is notated only once.

 Accidentals are <u>never</u> transferable at the octave. The above notwithstanding, many natural signs have been inserted in many places as precaution. Their absence elsewhere does not negate the above principle.

2) ⟦: :⟧ —Keep repeating music inside the bracket without attempting to coordinate with others.

3) ▽ Left hand cue.

4) Horns, Movement I, etc.: Depress the valves for the approximate pitches marked (slur) - maintaining implied shape of line-and blow lots of air (not a gliss).

5) Trumpets and trombones: unless otherwise specified, use straight mute whenever con sordino is called for.

6) Percussion: Cymbals always mean suspended cymbals except where crash cymbal and sizzle cymbal are noted.

Score in C

Jean Ritchie

(born 1922)

Jean Ritchie hails from a well-known singing family in the Cumberland Mountains of Kentucky, where she grew up learning guitar and dulcimer as well as singing. Her forebears had emigrated from Scotland in 1768 to Carr's Fork on Troublesome Creek, in eastern Kentucky. Over the generations they preserved the ballads, love plaints, and play-parties of their Scottish, Irish, and English ancestors. In Jean Ritchie's youth, her favorites were not the synthetic "hillbilly" numbers or Tin Pan Alley tunes, but the still-living folk tunes, such as "Barbry Ellen" and "Lord Randall." In her maturity she has become an authority on folk music and has established a major reputation as a songwriter in the Southern Appalachian folk style.

Ritchie was born in Viper, Kentucky, the youngest of fourteen children. She graduated Phi Beta Kappa from the University of Kentucky at Lexington, intending to enter social work. However, when she returned home after graduation, World War II had begun, and she responded to the shortage of teachers; for a time she served as Superintendent of Schools in Perry County. Later she turned to social work and folk singing. She worked as a music counselor in the Henry Street Settlement on New York's Lower East Side. As she performed in schools and colleges, she was encouraged by the eager reception of Appalachian folk song.

In the late 1940s Ritchie met the folk song collector, scholar, and singer Alan Lomax. He invited her to appear on his radio show, and he recorded her songs for the Library of Congress Archives of American Folk Song. In 1948 Ritchie sang at Columbia University and at Town Hall in New York, launching an international career, and in 1950 she began making commercial recordings of folk song. Her performances have appeared on the Elektra and Folkways labels. In 1950 she met and married the photographer George Pickow, with whom she had two children.

Like Ruth Crawford Seeger, at about the same time, Jean Ritchie began to assemble folk songs into collections, publishing *The Swapping Song Book* and *A Garland of Mountain Song*. In 1952 she received a Fulbright grant for research in the British Isles on the origins of American folk song, in the reverse manner of the British ethnomusicologist Cecil Sharp, who discovered British songs in the Appalachians.

Back in the United States, in 1955, she wrote *Singing Family of the Cumberlands*, a history of her family and its heritage in folk music. In the 1960s, folk music entered the mainstream of popular American culture, in significant part because of her work,

and Jean Ritchie performed at international music festivals, officially representing the United States at folk conferences in Mexico and Canada, as well as in the United States. The particular Appalachian idiom with which she became identified is singing and playing mountain dulcimer. She was one of the original directors of the Newport Folk Festival and performed there many times. She has served on the folklore panel of the National Endowment for the Arts, and has received proclamations from the State of Kentucky and the Congress of the United States for her contributions to preserving folk culture.

Ritchie wrote the score for the television film *Blue Diamond Mines*. Among her own songs are "The L and N Don't Stop Here Anymore," presented here, "Sweet Sorrow in the Wind," "Black Waters," West Virginia Mine Disaster," "One, I Love," and "Come Far Away, Marnie." Her compositions are published by Geordie Music Publishing Company, 7A Locust Avenue, Port Washington, New York 11050. "The L and N Don't Stop Here Anymore" is contained in the collection *Celebration of Life: Jean Ritchie, Her Songs, Her Poems* under her pseudonym 'Than Hall.

The L and N Don't Stop Here Anymore

'Than Hall {Jean Ritchie}

O when I was a curly-headed baby,
My daddy set me down upon his knee;
Said, "Son, you go to school and learn your letters,
Don't be no dusty miner like me.
Chorus
For I was born and raised at the mouth of the Hazard Holler.
Coal cars roarin' and a-rumblin' past my door;
Now they're standin' rusty, rollin' empty,
And the L and N don't stop here anymore.

I used to think my daddy was a black man
With scrip enough to buy the company store,
But now he goes downtown with empty pockets
And his face as white as February snow.
Chorus

Last night I dreamt I went down to the office
To get my payday like I done before;
Them old cudsy-vines had covered up the doorway
And there was trees and grass, well a-growin' right through the floor.
Chorus

I never thought I'd live to love the coal dust;
Never thought I'd pray to hear the tipple roar,
But, Lord, how I wish that grass could change to money,
Them greenbacks fill my pockets once more.
Chorus

© 1963, 1971 Jean Ritchie. Geordie Music Publishing Company.

Lucy Simon

(born 1940)

Lucy Simon made her Broadway debut with *The Secret Garden*, for which she received Tony and Drama Desk nominations, the Drama Loge Award, and a Grammy nomination for the recording of the score. She collaborated with Susan Burkenhead and Erica Jong in *Fanny Hack-about Jones*, which was produced at the Long Wharf Theater in New Haven, Connecticut. She also wrote songs for the off-Broadway hit *A...My Name is Alice*. Simon also wrote and produced songs and the soundtrack for the HBO movie *The Positively True Adventures of the Alleged Texas Cheerleader Murdering Mom*.

Lucy Simon received two Grammy Awards for the album *In Harmony*, for which she was both writer and producer, and she recorded two solo albums for RCA Records. She began her professional career at age sixteen with her sister Carly, as part of The Simon Sisters. She lives in New York with her husband, David Levine, and their children, Julia and Jamie.

Marsha Norman receives equal billing in the score presented below, as lyricist of *The Secret Garden*. She received the 1993 Pulitzer Prize for her play *Night Mother*, which also won four Tony nominations, the prestigious Hull-Warner Award from the Dramatists' Guild, and the Susan Smith Blackburn Prize. It has been translated into 23 languages and has been performed around the world.

Other renowned plays by Marsha Norman include *Getting Out*, cited by the American Theatre Critics Association; *Sarah and Abraham*; the one-acters *Third and Oak: The Laundromat* and *The Pool Hall*; *Loving Daniel Boone*; and *The Hold-Up*. The last five plays were premiered at the Actors Theatre of Louisville. Her first novel, *The Fortune Teller*, appeared in 1987 and has been sold as movie rights for a film to star Anne Bancroft.

Marsha Norman received a Tony Award and a Drama Desk Award for the Broadway musical *The Secret Garden*. She has received grants and awards from the National Endowment for the Arts, the Rockefeller Foundation, and the American Academy and Institute of Letters.

Come to My Garden

Play by Marsha Norman

Music by Lucy Simon

[Warn] **Colin:** *"You must come back tomorrow afternoon after you're through working, and have supper with me and tell me everything you've done."*

Mary: *"I'd like that. Goodnight, then."*

[Cue] **Colin:** *"Goodnight, Mary"*
[Mary starts to exit]

© 1991, 1993 ABCDE Publishing, Ltd. Administered by WB Music Corp. All rights reserved.
Reprinted by permission.

286

287

Natalie Sleeth

(1930–1992)

Born Natalie Allyn Wakeley in Evanston, Illinois, Sleeth began piano lessons at the age of four and was nurtured in her childhood by musical parents. She earned a Bachelor of Arts in music at Wellesley College in 1952. She married Ronald E. Sleeth, a Methodist clergyman and professor of homiletics. They lived in the university communities of Nashville, Evanston, Denver, and Dallas.

While living in Dallas, Natalie Sleeth attended a course taught by Lloyd Pfautsch at Southern Methodist University, and upon his recommendation she published her first work, the anthem "Canon of Praise" in 1969. Its success was immediate, and her subsequent pieces of sacred choral music have seen international publication and acceptance. She wrote her autobiography, *Adventures for the Soul*, in 1987, and is the subject of a 1990 videotape, *Words and Music*. West Virginia Wesleyan College and Nebraska Wesleyan College awarded Natalie Sleeth honorary doctoral degrees in 1989 and 1990 respectively.

In *Adventures for the Soul*, Sleeth recounts the genesis of "Hymn of Promise," the composition presented here:

> In the spring of 1985, I seem to have been much involved in pondering the ideas of life and death, spring and winter . . . Good Friday and Easter, and the whole reawakening of the world that happens every spring. . . . One evening we entertained a friend for supper, and he too had been pondering such themes. He even shared a work by T.S. Eliot, in which there was a phrase something like "in our end is our beginning." That was virtually the catalyst for the form of the text of "Hymn of Promise," which I wrote the next day or two. . . .
>
> I worked on the words very carefully, choosing just the right "pairings," attempting to get across the idea of something inherent in something else, even though unseen. I even bought a tulip plant (although it was in bloom and bright yellow) to contemplate the idea of the "bulb" leading to the flower even though the bulb itself seems dead.

"Hymn of Promise" was first performed as an anthem at the Pasadena Community Church in St. Petersburg, Florida, in March 1985, during a festival weekend and concert of the author's music. Sleeth offers this option for performance: "Since the word 'hymn' is in the title, this suggests that perhaps a congregation could sing it, and since

it is basically a unison number (with Alleluia descant on the last verse) that is possible." The version printed here is the congregational hymn, which appears in the *United Methodist Hymnal* of 1989.

> Soon after writing "Hymn of Promise," my husband, Ronald, became ill with what turned out to be a terminal malignancy. As the end neared he asked me to use "Hymn of Promise" as one of the anthems at his funeral service, which was done. Subsequently at publication I dedicated the piece to him. Again, a "mysterious" set of circumstances, but—perhaps again—a sort of "preparation."

Bibliography

Sleeth, Natalie. *Adventures for the Soul*. Carol Stream, IL: Hope Publishing Co., 1987. Pp. 113–15.
Young, Carlton R. *Companion to the United Methodist Hymnal*. Nashville: Abingdon Press, 1993.

Hymn of Promise

Words and music by Natalie Sleeth

1. In the bulb there is a flow-er; in the seed, an ap-ple tree;
2. There's a song in ev-ery si-lence, seek-ing word and mel-o-dy;
3. In our end is our be-gin-ning; in our time, in-fin-i-ty;

in co-coons, a hid-den prom-ise: but-ter-flies will soon be free!
there's a dawn in ev-ery dark-ness, bring-ing hope to you and me.
in our doubt there is be-liev-ing; in our life, e-ter-ni-ty.

In the cold and snow of win-ter there's a spring that waits to be,
From the past will come the fu-ture; what it holds, a mys-ter-y,
In our death, a res-ur-rec-tion; at the last, a vic-to-ry,

un-re-vealed un-til its sea-son, some-thing God a-lone can see.

Copyright © 1986 Hope Publishing Co., Carol Stream, IL 60188. All rights reserved.
Used by permission.

Grace Wiley Smith

(born 1946)

Grace Wiley Smith grew up in Sapulpa, Oklahoma, a city in the Creek Nation. In her childhood, as a Creek she identified strongly with the traditions as well as with the difficulties of Native American life. She attended the University of Central Oklahoma, Edmond, for her bachelor's and master's degrees in music education, and continues there at this writing as Professor of Flute. Among the teachers who became her role models are Robert Dillon, for his composition teaching, and Feodora Steward, her flute teacher and "friend for life," who was the primary influence in encouraging Smith to become a composer. Smith recalls no active discouragement in her development as a musician because she is a woman, although she encountered few women in leadership roles. One who is notable is a female band director in junior high school, who proved to Smith that music leadership was not a closed field.

Grace Wiley Smith also is associated with the Indian Education Program of the Edmond Public Schools, the Indian Education Exposition in Norman, Oklahoma, the Red Earth Artist Presentation, and the Seminole Nation Student Honor Reception. She is married and has a daughter.

She writes music under the name G. Wiley Smith

> in order to have my music taken seriously, and to honor my family, especially my father. My maiden name Wiley comes from my great grandfather, whose name was Willie Cuntullie (meaning "virgin land"). His name was changed to Wiley for convenience of record keeping in Oklahoma during the days following the Trail of Tears.

Whisper on the Land (a composition related *A Distant Dream*, the work presented below) was written to honor Smith's father, likewise a full-blooded Muscogee Creek Indian.

> The piece reflects native American music and is particularly reminiscent of the native flute. There gradually begins a battle between the cultures as more and more contemporary Western influences are introduced. This conflict, which many generations of Native Americans have experienced, continues today. I personally have lived with many conflicting values and traditions. Although the Indian culture has all but been eliminated, it still remains a "whisper," as heard in the closing measures.

> The structure of [*A Distant Dream*, 1995] is a three-part form, from the opening theme,

to the middle section [beginning at m. 29] and its faster movement, and concluding with the A′ return section [m. 45]. This was not completely preplanned. I find it interesting to look back over a piece after finishing it to see what has made it come to what I feel is a logical conclusion. In *A Distant Dream* I used the technique of unison between the instrument and the performer's voice, humming. This occurs at the end, reminiscent of Native American culture fading away.

This piece was conceived as a work embodying cultural conflict. At a program on Indian culture at the University of Oklahoma, Doc Tate, a noted Indian flutist and painter, performed native flute music. Smith responded to it on the spot by extemporizing on his playing while drawing upon standard techniques. She later enlarged on the musical idea and created the present composition.

Other works by Grace Wiley Smith center on the flute, whether the solo instrument, alto flute, or flute with piano. Her music is reprinted by her kind permission, and is available from Harmon Richard Music, 3114 Prairie Avenue, Edmond, Oklahoma 73013 USA.

A Distant Dream

G. Wiley Smith

295

Joan Tower

(born 1938)

Born in New Rochelle, New York, Joan Tower spent her childhood in South America, where her father worked as a mining engineer. She returned to the United States in 1955, attended Bennington College, Vermont, from 1958 to 1961, where she received a bachelor's degree. She earned her master's and doctorate in 1967 and 1978 respectively. In 1969 she founded and served as pianist for the Da Capo Chamber Players in New York; the group specialized in performing new music and won a Naumburg Award in 1973.

Many prizes, awards, and commissions have come to Joan Tower, including three fellowships from the National Endowment for the Arts, a Guggenheim Fellowship, and commissions from the Koussevitzky Foundation (for *Music for Cello and Orchestra*) and the Naumburg Foundation. From 1985 to 1987 she was Composer-in-Residence for the St. Louis Symphony, and her *Silver Ladders*, for orchestra, received a Kennedy Center Friedheim Award in 1988 and a Grawemeyer Award in 1990. She served on the faculty of Bard College in the 1970s and returned there in 1988, after the St. Louis residency, to assume the position of the Asher Edelman endowed chair and department head. In 1993 she was named one of two finalists for the Pulitzer Prize in Music, for the Concerto for Violin and Orchestra.

For Tower, essential compositional concerns revolve around energy and interaction of forces: she has alluded, for example, to the prevalence of titles drawn from the physical world, mechanics, and even the properties of minerals. These include *Black Topaz* (1976), for chamber ensemble; *Platinum Spirals* (1976), for solo violin; *Red Garnet Waltz* (1977), for piano solo; *Clocks* (1985), for guitar; and the highly important *Silver Ladders* (1986), for orchestra. The last-named work symbolically captures the molten, gossamer qualities of silver through fluid solo lines. They are juxtaposed against a panorama of powerful, rising symmetries of scales, ladder-like, into space. The varying textures of the work depict the alternately light or heavy appearance of silver, or its solid or fluid states. John von Rhein, critic of the *Chicago Tribune*, wrote that *Silver Ladders* is "an absorbing journey of sounds evolving in space . . . its sheer momentum is irresistible."

Natural images likewise are represented in Tower's work. *Sequoia* (1981) was her first major orchestral composition; it quickly entered the repertory, with performances

by the orchestras of Saint Louis, New York, San Francisco, Cincinnati, Washington, D.C., Tokyo, and London.

Tower writes about the work contained in this anthology:

> *Night Fields*, my first string quartet, was commissioned by Hancher Auditorium at the University of Iowa and the Snowbird Institute for the Arts and Humanities. The commission was funded, in part, by Chamber Music America with funds from the Pew Charitable Trusts. The quartet is dedicated with affection and admiration to the Muir Quartet. The title was conceived after the work was completed and provides an image or setting for some of the moods of the piece: a cold, windy night in a wheat field lit up by a bright, full moon, where waves of fast-moving colors ripple over the fields occasionally, settling on a patch of gold.

In an interview with the present author on 2 October 1995, Joan Tower pointed to the action and reaction of line, and the concern for spatial arrangement, in *Night Fields*:

> Going, staying, retreating in space is a concern. The cooperation of energy is my main preoccupation, with each entity motivated by something. Context can nourish or kill an impulse. Rhythm and motive were the motivating factors of the work, most noticeably in shifts of tempo and motivic interactions.

The work is in three connected movements, the outer ones dramatically assertive, and the slower, middle movement lyric. Tower chose the title after the piece was already completed. Like many other composers who make programmatic parallels with a work, she draws attention to processes of mind in *Night Fields* rather than to literal picture-painting.

Tower's process of composing begins with a sense of time and its expanse.

> Here I had the idea of length, about 15 or 16 minutes. I bring furniture into a room of that size. I'm very intuitive and *very* slow in composing; I have to live with ideas; the perception has to settle down into a happy perception. All this is a long and torturous process.

Joan Tower repeatedly signals her debt to performers. Her years as a pianist playing new music helped give her compositions a special sensitivity to their needs and interests. "Players who receive my music well make me think I can compose," she insists. With wry but telling understatement, Tower observes that her works—contrasting with a number of "moderns"—are played "more than once."

If the process of composing *Night Fields* was torturous, the overwhelmingly positive reception by performers, critics, and audiences has more than compensated. The Muir Quartet, which premiered *Night Fields* in 1993, has played it extensively in the United States and abroad. It has also been performed frequently by the Lydian Quartet, in residence at Brandeis University, and the Maia Quartet, in residence at Juilliard. "It is very reassuring to have these quartets repeatedly playing this piece," says Tower. "To me, any piece becomes its own 'fuel' for repeated performances." Writing in the Pittsburgh *Post-Gazette* on 12 December 1995, Robert Croan viewed the work as a product of "one of America's most important serious composers. . . . Its 16 minutes contain a gamut of human expression couched in a harmonically colorful aural garb."

In the Salt Lake City *Deseret News* of 18 July 1994, following an early performance,

William S. Goodfellow also quoted Tower's sentiments about "'the intimidation of being on the same program with Beethoven.' But she didn't sound intimidated, and neither did her new string quartet. Initially dubbed 'Night Fields,' and then 'Night Winds,' it has now gone back to its original title." (With her characteristic humor, Tower has stated that Peter Schickele talked her out of "Night Winds": a title "too explicit.") Goodfellow reports hearing

> more winds than fields in this bold, often unsettling score, which Tower says is meant to evoke "a windy night, very cold, with a bright moon and a cold field." In the first section, the tension is most effectively maintained. Yet, beneath the forbidding exterior, there is also an eerie subtext whose deceptive calm carries over to the second movement. Despite the lighter bowings, here too one feels a sense of strain and upward movement—this last something of a Tower trademark—leading to the agitated brilliance of the finale.

Bibliography

"Joan Tower." Composer biography and catalog. New York: G. Schirmer (a division of Music Sales): 1988/1991.

Discography

Joan Tower, *Black Topaz*. Contains *Night Fields*. The Muir String Quartet. New World Records, 1995. CD 80470–2.

Night Fields

Joan Tower

I.

300

301

303

305

306

307

308

309

312

313

317

318

Nancy Van de Vate

(born 1930)

Nancy Van de Vate was born in Plainfield, New Jersey. She now lives in Vienna and holds dual American and Austrian citizenship. She attended Eastman School of Music from 1948 to 1949 and she completed her Bachelor of Arts in Music at Wellesley College. She earned a Master of Music in composition at the University of Mississippi in 1958 and a doctorate at Florida State University in 1968. She pursued post-doctoral work in electronic music composition at Dartmouth College and the University of New Hampshire.

Van de Vate's compositions are heard frequently on major music festivals around the world, including the Japan Society for Contemporary Music in 1991, the Vienna Music Summer of 1992, Ultima 1992 in Norway, Aspekte at Salzburg in 1989 and 1990, Musica Viva in Munich in 1989, Poznan Spring in Poland in 1984, Wratislavia Cantans in Wroclaw, Poland in 1990, and Soro Music Festival in Denmark in 1994. Her music has been heard in at least 36 countries on five continents. Virtually all her compositions, representing a wide spectrum of forms, have been recorded, mainly on Vienna Modern Masters compact disks.

Nancy Van de Vate has received commissions from, among others, the National Endowment for the Arts, the American Association of University Women, Meet the Composer, and the Money for Women Fund. She has been a resident fellow at Yaddo, Ossabaw Island, and the MacDowell Colony in the United States; the Tyrone Guthrie Centre at Annaghmakerrig in Ireland; the Brahmshaus in Baden-Baden, Germany; and the Künstlerhaus Boswil in Switzerland. As *The Economist* observed, Nancy Van de Vate has fared remarkably well on the international scene, despite the issue that "being a women increases the difficulties. Of the composers cited in standard reference works, only 5–6 per cent are women—which may be the lowest representation in any field of endeavor, including aerial warfare and coal mines." Reviewing the 1992 Vienna premiere of Van de Vate's Concerto for Violin and Orchestra, the writer quotes the conductor of the Vienna Summer Festival, Hildegard Siess: "Van de Vate is one of the major composers now working, never mind the sex."

In the composer's view,

> Although my music is not stylistically conservative, I do regard it as growing out of and continuing the mainstream tradition of Western music which has been with us for more than a thousand years. I make no effort to eliminate those elements which

319

have marked Western music during most of its history—melody, coherent rhythm, structure, vertical sonority, tension-resolution relationships, idiomatic use of instruments and voices, and the intention of being expressive. . . . I have made use of virtually every contemporary compositional technique, always with the aim of writing dramatic, understandable, and expressive music.

Foreign elements have influenced my music since 1975, when I moved to Hawaii and first had substantial exposure to Asian music. [I spent 1982–86 in Indonesia, where] gamelan and other vivid tone colors pervade one's daily existence. . . . [I traveled] from Jakarta to Polish and Czechoslovakian music festivals. . . . In December 1985 I moved permanently to Vienna. Composers whose music has especially influenced my own work are Bartók, Stravinsky, Varèse, and Penderecki . . . as well as Giya Kancheli and Sofia Gubaidulina. . . . I am particularly drawn to music of great emotional intensity, and I value that quality in my own works.

Since my study of electronic music in 1972 . . . and my introduction to Asian and exotic music in 1975, I have become increasingly interested in timbre. My mature works are also characterized by a concern with dramatic contrast—dynamic, textural, rhythmic—an interest in the large forms, and movement among varying levels of dissonance. For example, large, extremely dissonant clusters often alternate with lyric melodies which may contain archaic elements of modality or movement in parallel fifths. Since the late 1970s I have composed primarily for large ensemble.

In the entry on Van de Vate in *Contemporary Composers*, Stephen W. Ellis states:

It is with orchestral works that Van de Vate has made her greatest impact. . . . *Dark Nebulae* (1981) confirms immediately the composer's transfer to sonorism, wherein staggered blocks of sound supplant customary thematic development. . . . *Journeys* (completed in Jakarta, Indonesia in 1984) is another important marker in Van de Vate's output. The work's title reflects both external and internal movement.

Journeys contains a merger of various cultures, with a Southeast Asian coloration of percussive climaxes of this "autobiographical showcase." In similar fashion *Distant Worlds* (1985) calls on a solo violin voice to convey, in the composer's words, "a great love of travel to obscure places."
Ellis concludes:

Since 1985 there has been a tendency for her music to sound alarms—alerting listeners to be watchful and concerned citizens of the world. Sometimes the alarm is programmatically direct, as in the symphonic "tragic landscapes" of *Chernobyl* (1987), *Katyn* for orchestra and chorus (1989), and the *Krakow Concerto* for percussion and orchestra (1988); in other works such as *Dark Nebulae*, *Distant Worlds*, and the First Violin Concerto, the call to attention is more abstract but no less visceral. . . . In all, Van de Vate's music has become the embodiment of fearful times—a music of dauntless immediacy that does not sacrifice satisfying compositional precepts.

In 1992, the periodical *Musik und Bildung* published extended comments by Wilfried Burkhardt on the meaning and structure of *Chernobyl*. The following outline points out the primary phases of the programmatic work, which runs thirteen minutes in length:

 A mm. 1–70 Explosions and Prelude to Meltdown
 B mm. 71–130 Answer of Humanity

B¹ mm. 71–94	Weeping
B² mm. 94–102	Mourning
B³ mm. 103–112	Hope
B⁴ mm. 113–130	Adversity (Exodus)
A' mm. 131–142	Postlude

The disaster at Chernobyl, in the former USSR, in April 1986, resulted in a partial meltdown of a nuclear power plant. So widespread was the radioactive contamination, and such an alarm about poorly controlled nuclear energy did the event offer, that much of Europe and indeed the entire world was shocked into rethinking the nuclear question.

The United States National Endowment for the Arts commissioned *Chernobyl*, and in preparing to compose it Van de Vate viewed two videotapes showing the aftermath of the accident. She determined "to create a work which would express universal feeling about the event and its meaning for all people." The first half of the piece is atonal, resembling by its continuous crescendo Penderecki's *Threnody to the Victims of Hiroshima*. The second half is neo-tonal, with more-intimate sections concerned with weeping but also renewed hope. As Stephen Ellis remarks, however, the conclusion stifles optimism with its return to the weeping motive.

Chernobyl has received numerous performances, particularly in Europe, and many reviews of the compact disk recording. Writing in the Vancouver *Province* of 28 May 1989, Ray Chatelin finds that the work "carries your mind and heart. . . . If one nuclear accident could cause such widespread horror throughout Europe, what then would even a limited nuclear war do? Van de Vate captures those impressions [with music that] transcends its art form into higher meaning." According to the British Music Society *News* of December 1989, "hers is a unique and distinctive voice . . . palpably apparent in her disturbing orchestral work *Chernobyl*, . . . the response of a concerned artist and compassionate being to man's dilemma." The review in *American Record Guide* of May 1989 finds that Van de Vate's work concludes "with a tonal sadness; humanity battles with the monster, the tragic result."

Bibliography

Anonymous. "Women in modern music: air combat would be easier." *The Economist*, September 19–25, 1992.

Burkhardt, Wilfried. "*Tschernobyl*: Music im Angesicht der Katastrophe." *Musik und Bildung* 6 (1992):58–61.

Himmelbauer, Regina. "Nancy Van de Vate: Ein Porträt der Komponistin, Feministin, und Plattenproduzentin." *Tritonus* 3 (1994):4–5.

Morton, Brian, and Pamela Collins. "Nancy Van de Vate." In *Contemporary Composers*. Chicago and London: St. James Press, 1992. Pp. 939–41.

Van de Vate, Nancy. Autobiography provided by the composer for this writing.

Discography of *Chernobyl*

Conifer CDCF 168 (1988–92).

VMM CD (Vienna Modern Masters) 3010 (1992). Conductor: Szymon Kawalla.

Chernobyl

Nancy Van de Vate

© 1987 by Nancy Van de Vate.
Used by permission of Vienna Masterworks.

323

35

331

334

342

343

344

345

ORCHESTRA

$\boxed{13'}$

Flutes 1, 2
Flute 3/Piccolo
Oboes 1, 2
Oboe 3/English Horn
Clarinets 1, 2 in Bb
Clarinet 3 in Bb/Bass Clarinet
Bassoons 1, 2
Bassoon 3/Contrabassoon

Horns 1, 2, 3, 4 in F
Trumpets 1, 2, 3 in Bb
Trombones 1, 2
Bass Trombone
Tuba

Percussion 1, 2, 3

1) Bass Drum
 Small Snare Drum
 Bell Plate
 * Roto-toms (5-7)
 Medium Suspended Cymbal
 Flexatone
 Glockenspiel

2) Medium Suspended Cymbal
 ** Siren
 Chimes
 Xylophone
 Claves
 Large Wood Block
 Flexatone
 Medium Snare Drum

3) Large Tam-tam
 Medium Snare Drum
 Bass Drum
 Medium Suspended Cymbal
 4 Temple Blocks
 Medium Wood Block
 Vibraphone

Timpani
Harp
Celesta
Piano
Violins
Violas
Violoncellos
Double Basses

<u>Percussion I</u> - Ordinary tom-toms may be substituted for roto-toms.

<u>Percussion II</u> - A siren-whistle may be substituted for the siren.

Score is in C. Piccolo, celesta and xylophone sound one octave higher than written and glockenspiel two octaves higher. Double basses and contrabassoon sound one octave lower than written.

Tied notes should be repeated only as often as necessary to sustain volume, and breathing and bow changes should be staggered. Fresh attacks should be avoided as much as possible when tied notes are repeated.

Strings should divide in the usual manner unless otherwise indicated. In measure 53, mutes should be removed one by one.

‖: ♪ ⟶ Repeat pattern for duration indicated.

In measure 24, <> should be sounded as a pulsation rather than as a fresh attack.

In measures 44-52, the pianist should stroke the bass strings about ten inches from the dampers and in such a way that the sound is both continuous and even. Rubber xylophone mallets are suggested.

 right hand ⟶
 left hand ⟵
 right hand ⟶ etc.

A saw may be substituted for the flexatone, if desired.

Percussion players may be positioned as below, if the starred instruments are to be shared.

 Timpani II Med. susp. cym.* I Bass Drum* III
 Flexatone*

Pianissimo clusters for the entire orchestra should be carefully balanced so that no single instrument or group of instruments stands out.

**CHERNOBYL was completed with the assistance of
a 1987-88 Composer's Fellowship from the
National Endowment for the Arts.**

Judith Weir

(born 1954)

Judith Weir was born in Cambridge, England, but her parents instilled in her a love of folk music from their native Scotland. At first she studied composition with John Tavener. For a semester in 1972, she studied computer music with John Vercoe at the Massachusetts Institute of Technology, and from 1973 to 1976, she worked in composition with Robin Holloway at King's College, Cambridge. At Tanglewood, in the summer of 1975, she worked with Gunther Schuller, with whom she wrote her first published work, the woodwind quintet *Out of the Air*. A string of major residencies followed, including the Southern Arts Composer-in-Residence (1976–79), a position at Glasgow University (1979–82), and a two-year fellowship at Trinity College, Cambridge. These were followed with a Guinness Composer-in-Residence position at the Royal Scottish Academy of Music and Drama, in Glasgow, from 1988 to 1991. In 1992 she moved to London. Weir has received major commissions from the British Broadcasting Corporation, Boston Symphony, and the opera companies of Glasgow (for *King Harald's Saga*, 1979), Cheltenham Everyman Theatre (for *Night at the Chinese Opera*, 1987), and the Glasgow Theatre Royal (for *The Vanishing Bridegroom*, 1990).

Judith Weir has achieved a remarkably large and diverse catalog, in addition to opera. Other dramatic works include *Hans the Hedgehog* (1979), after Grimm; *The Black Spider* (1984), a children's opera; chamber stage works such as *Scipio's Dream* (1991), for soloists, SATB ad libitum, and chamber ensemble; and *The Small Moments in Life* (1992), a happening with M. Duncan. Orchestral music is represented by *Ride over Lake Constance* (1984), *Variation on "Sumer is icumen in"* (1987), *Heroische Bogenstriche* (1992), and *Music Untangled* (1992). Her chamber music ranges from *The Bagpiper's String Trio* (1985) and *Spij dobrze* (Pleasant dreams, 1983), for double bass and tape, to *I broke off a golden branch* (1991) for violin, viola, cello, double bass, and piano.

Weir has composed music for keyboard, including two piano pieces—*The Art of Touching the Keyboard* (1983) and *Roll off the ragged rocks of sin* (1992). Her vocal works include *Lovers, Learners, and Libations: Scenes from 13th-century French Life* (1987), for solo voices and early instruments; *A Spanish Liederbooklet* (1988), for soprano and piano; and "The Alps" (1992), on poems of Emily Dickinson, for soprano, clarinet, and viola. Choral works include the SATB *Ascending into Heaven* (1983), after Hildebert of Lavardin, eleventh century; the SATB *Illuminare Jerusalem* (1985), on fifteenth-century Scottish texts; and *Missa del Cid* (1988), for SATB divided parts.

The Consolations of Scholarship is a music drama in the form of a Yüan opera, from

China in the thirteenth and fourteenth centuries. It was commissioned by Musicon of Durham University in England, with funds provided by the Arts Council of Great Britain. The first performance was given by Linda Hirst with the Lontano Ensemble, conducted by Odaline de la Martinez at Durham University, on 5 May 1985. The London premiere, by the same performers, took place at St. John's Smith Square on 15 October 1985. Its duration is about 25 minutes.

The Novello score offers the following introduction and plot synopsis: Yüan plays, the earliest form of drama in China, were written and acted by native Chinese while they were under the domination of Kublai Khan's armies. The plays are simple and robust in character, but they deal with philosophical issues, often satirically. Apparently the original performances combined speaking, singing, instrumental interludes, and mime. *The Consolations of Scholarship* follows literary but not necessarily musical performance style. It borrows extensively from the plays *The Orphan of Chao* by Chi Chun-hsiang (a subject also treated by Voltaire) and *A Stratagem of Interlocking Rings*, by an anonymous playwright. Other borrowings are from earlier Chinese poetry, Confucian philosophy, Marco Polo's travels, and the Mongolian legal code of 1291. The source of the composer's information on Yüan drama is Liu Jeng-en, *Six Yüan Plays* (London: Penguin Classics, 1972).

The plot, the setting of *The Consolations of Scholarship* is the great kingdom of Tsin. Two men hold the emperor's attention—the warlike General K'han and the virtuous government official Chao Tun. K'han implicates Chao in a plot to overthrow the Emperor, and Chao is forced to commit suicide. His wife manages to escape with their newborn son but expires just as she reaches the cave of a hermit, who had received a kindness from Chao in the past. Knowing only who the boy is, the hermit surmises that some evil deed must be avenged in the future, and he brings up the boy in an ascetic and enlightened way. As a student of the Confucian classics, the boy travels to the capital to study. There, in a library he reads about his father's death. At that moment General K'han passes, planning to overthrow the Emperor. A heavenly immortal intervenes to turn the General back to the right path, throws a scroll with a classical inscription at the General, and vanishes. Unable to read the inscription, General K'han seizes the boy, who by chance is coming from the library. Chao's son turns what is in fact a warning to the general to desist from his plot into an opportunity for revenge. Speedily he interprets for the General a "divine encouragement."

The General rides off to stage his coup, but the boy takes another route and warns the Emperor of the plot before the General arrives. The Emperor proclaims, "henceforth throughout our kingdom a new life shall begin," as he sentences the General and restores the boy's estates. But, as the composer's synopsis concludes, "a final military tinge to the music suggests that things will go on much as before."

The excerpts given here are the conclusion of the opera, from the purposeful misleading of General K'han in the "Interpretation Scene" through the "Chase to the Palace," with each principal arriving by different routes, to the final scene of "The Emperor's Decree."

According to Rosemary Johnson, International Promotions Manager for the publisher, Chester Music, *The Consolations of Scholarship* is a 1985 study for the subsequent, extended opera *A Night at the Chinese Opera*, written in 1987.

Discography

The Consolations of Scholarship. Barcelona/Novello Records NVLCD 109 and NVLC 109.

The Consolations of Scholarship (excerpts)

Judith Weir

8. Interpretation Scene

Reprinted by permission of Chester Music New York, Inc. (ASCAP).
International copyright secured. All rights reserved.

What are these words on the scroll? *You there! leaving the library gate,*

I am General K'an: *Read these words to me or die!*

Subito! (♩=69: Slow and serene)

SPOKEN (aside)

General K'an! The villain who killed my father! *as Your Excellency wishes:* "A

thousand leagues the water is blue: the "oracle prophecies ten long lives."

|610|

SPOKEN (aside : thoughtfully)
A warning from heaven that the Emperor's rule will continue.

[still aside — as if suddenly struck by an idea]
Revenge!
(poco)
(sempre p)

Very fast (tempo colla voce)

As fast as possible (approximately the speed of a horse-race commentary)

My lord, as I see it, above the word "thousand" there comes the word "water" and under the "thousand" there comes the word "leagues," and doesn't that give your surname K'an? and

here under "oracle" comes the word "prophecy", under the "prophecy" comes the word "ten"; and the scroll is ten feet long and the emperor's palace is ten minutes' journey by carriage; so in only ten

minutes our nation will gain a great triumph, thanks to the courage of General K'an; such is the

(colla voce)

will of the gods and the wish of

♩60: Expansive

Clearly my plans are blessed by heaven [you stupid old fool.]
GENERAL (expansively) BOY (aside)

Nothing be-tween myself and the throne: [You think so?]

GENERAL BOY

640

attacca No. 9

Long life to all in my new kingdom [I wouldn't bank on it] Down the avenue, to my new broad

GENERAL BOY GENERAL

9a. the Chase to the Palace

366

367

9b. The Emperor's Decree

Very slow and huge: ♪ 66

[680]

Lyrics (mezzo): The heav'n-ly laws reach far and wide: Kneel and hear the

Em—peror's de—cree. May the man who was wronged be given his

just re-ward. May the wicked usurper be given

repeated beatings with a sharpened stick Henceforth, throug.

—out our kingdom a new life shall be-gin.

Gillian Whitehead

(born 1941)

Gillian Whitehead was born in Whangarei, New Zealand. She is one-eighth Maori and very much drawn to her country's environment and personality. She started composing at an early age and was always attracted to programmatic, folkloric, and literary associations. Whitehead attended the University of Auckland from 1959 to 1962, studying with Ronald Tremain, and Victoria University at Wellington, where she earned a bachelor's degree in music. She received a Master of Music at the University of Sydney in 1966, having studied with Peter Sculthorpe. In 1967 she worked with Peter Maxwell Davies in Adelaide and then in England. From 1978 to 1980 she was composer-in-residence at Northern Arts, Newcastle upon Tyne. From 1981 she was on the faculty at the Sydney Conservatorium and became Head of Composition there.

According to J.M. Thomson, in *Norton/Grove Dictionary of Women Composers*, Whitehead takes a leave without pay every second year to concentrate on composition. As a first-year student she wanted to compose music that was like Debussy in harmony, Webern in orchestration, and Dufay in structure. She makes consistent use of a number grid dealing with prime numbers and a "magic square." Such an approach extends into a serialized, holistic control of pitch and rhythm. Thomson finds that her works can at times be glowing and warm, at others they have a "steely, sinewy quality." Whitehead frequently cites the presence of nature in her work, "of birds, the sound of wind coming from nothing, the sound of rain and the great sense of space and the changing light."

A frequent but not exclusive theme in her output has been her Maori heritage. Instrumental works, and those which she personally finds representative, include her three string quartets: *Bright Forms Return* (1980), with mezzo-soprano; *Moon, Tides, and Shoreline* (1990); and *Angels Born at the Speed of Light* (1990). Among the vocal works that present her current ideas are three monodramas for solo voice and small ensemble: *Hotspur* (1980), *Eleanor of Aquitaine* (1982), and *Out of This Nettle Danger* (1983). She has written six chamber operas, including *Tristan and Iseult* (1975), *Bride of Fortune* (1989), and *The Art of Pizzicato* (1995). She identifies *Resurgences for Orchestra* (1989) as a major work for her in that genre.

Whitehead's work spans many types of scoring, such as *Bagatelles* (1986), for solo piano; *Antiphons* (1980), for brass ensemble; and *The Virgin and the Nightingale* (1986), on medieval poetry, a set of five songs for five soloists and vocal ensemble. In a communication for this anthology Gillian Whitehead writes,

I became a professional composer more by a process of eliminating all other career choices rather than by an initial decision! In New Zealand in the early sixties, before composition was taught as a major strand in universities for anyone male or female, to decide to become a composer was a highly unusual choice. Role models? All my composition teachers were men, which was fine, and many other prominent Australasian women composers of my generation were also taught by the same teachers. But it was a woman pianist, Tessa Birnie, who encouraged me to follow my creative vision, and it was the example of Katherine Mansfield which sustained me. She had left New Zealand to make a career as a short story writer in Europe. . . . Role models need not be of the same time [Mansfield died in 1923] or in the same career area—if you need one, you'll find one.

My formal compositional education was at a time when composition in universities was just beginning. I had dedicated and inspired teaching from such composers as Ronald Tremain, David Farquhar, Peter Sculthorpe, and Peter Maxwell Davies (Tremain and Davies were former Petrassi students), and I had nothing but encouragement from them all. At length, composition became accepted into the curriculum and became an intrinsic part of a hierarchical institution, turning it into an offered career choice rather than a discovered vocation. From my observation as a composition teacher, some talented students can feel threatened. This is of course common in any university department, but doubly so in an area where creativity and subjectivity as well as craft form the basis of assessment. Talented students can feel threatened also by the perception that both the industry and the teaching institutions are male-dominated. It is taking positive discrimination, particularly by appointing practicing women composers to university faculties, to reinstate the perception of equality that my generation had as students.

As composition is such an individual process, I think that, until there is a really sizable body of women's music—perhaps 50 years hence—any observations made now can only be fairly superficial. I suppose I believe that, at a level of craft and style, there is no perceptible difference between the way men and women approach composition (although sometimes I have suspected there is something, but I can't identify it). In non-abstract music, women will choose different themes and different texts, and approach them in different ways from men. For instance, most of the writers I have worked with have been women, and the central or fleshed-out characters in [my] opera or monodrama are women. I think composition is rather like literature—it's a spectrum. At one end are writers who could only be men, and at the other writers who could only be women, with a middle ground where gender is comparatively irrelevant.

The Journey of Matuku Moana was commissioned by the Danish-born cellist Georg Pedersen, with funding from the Performing Arts Board of the Australia Council. It is included on a CD of solo cello works by Australian composers on the Tall Poppies label released in 1996. Matuku Moana is the Maori name of the white-faced heron, which at some point introduced itself from Australia to New Zealand. When I was writing the piece, in Sydney in 1992, I was recovering from an illness. In my room I had a five-foot-tall wooden heron, of almost transcendental appearance, who became something of a symbol of recovery. When I subsequently moved to a small cottage that I now own in New Zealand, there were real herons stalking along the water's edge and roosting in the trees behind my house. The piece follows the voyage of the heron from Australia to New Zealand, and is tied up with my voyage of recovery.

Structurally the piece is based on a long series of strictly generated pitch groups, which are then interpreted freely. Subsequently, two doubles of this section appear, each

working with similar material in sections halved in length. A slower, simpler section that follows the first has its double, the fast, dancelike section toward the end. Interspersed through the piece are suggestions of birdsong, usually expressed in harmonics, which haunted me at this time: one call of the Australian currawong that sang outside my Sydney window, one call of the korimako—the New Zealand bell-bird that I heard constantly in my New Zealand house! The korimako concludes the piece.

The Journey of Matuku Moana

Gillian Whitehead

Reprinted by permission of the composer.

382

If necessary, the upper line through to the * below may be played an octave lower

Mary Lou Williams

(1910–1981)

A world-renowned jazz keyboard artist, Mary Lou Williams was for a long period considered the most important woman in jazz. She was born Mary Elfrieda Scruggs in Atlanta, Georgia. Her family was poor, and her mother supported the eight children by doing housework. Her mother, a pianist and a church organist, started to teach her daughter to play the piano when the child was four years old. The family moved to Pittsburgh, Pennsylvania, where Mary Lou Williams was introduced to concert music by her high school principal, although her focus on jazz had already taken hold.

In her teen years she began performing on the road in vaudeville shows. From 1929 to 1942, in the Kansas City area, she was associated with the Andy Kirk band, The Twelve Clouds of Joy, for which her jazz piano solos brought a particular distinction. In the early 1940s she moved to New York and began arranging for Benny Goodman, Duke Ellington, Earl Hines, Tommy Dorsey, and others. Her original compositions included "Froggy Bottom," "Big Jim Blues," and "What's your story, Morning Glory?" She had married saxophonist John Williams when she was sixteen, divorced him, and married the trumpeter Harold Baker within a short time. She and Baker began a small combo and started a mutually fruitful collaboration with Ellington, for whom Williams wrote "Trumpet no end." A residency at Cafe Society beginning in 1944 gave her time to concentrate on composing, and her *Zodiac Suite* (1945), originally a jazz trio, was performed the following year by the New York Philharmonic at Carnegie Hall. By the late 1940s the world of modern jazz had turned decisively to bebop. Mary Lou Williams wrote "Lonely Moments" and "Whistle Blues" in 1947 for Benny Goodman, and the bop fairy tale "In the Land of Oo Bla Dee" in 1949 for Dizzy Gillespie's big band.

In the early 1950s Williams figured among the front-runners of bop, collaborating with Dizzy Gillespie, among others, and she toured for two years, including a trip to Europe in 1952. A jazz club in Paris, Chez Mary Lou, was one proof of her lasting impression. A mainstay of the bop movement, she became a particular pillar for Thelonious Monk and Bud Powell. In 1955 she completed a recording for Jazztone but ceased performing to devote herself to charity work and religious studies. This phase culminated in her conversion to Catholicism in 1956.

Mary Lou Williams pursued her faith in various ways. She joined the Abyssinian Baptist Church of Harlem when Adam Clayton Powell was pastor. Along with Lorraine Gillespie, the wife of Dizzy Gillespie, Williams embarked upon a profound study of the

Catholic faith. Soon thereafter, however, Father Anthony Woods, her mentor in the faith, encouraged her to return fully to music.

She resumed performing in 1957, performing at the Newport Jazz Festival with the big band of Dizzy Gillespie and playing sections of her *Zodiac Suite*; and she returned to Newport in virtually a last appearance in 1972. Williams became somewhat disillusioned with the new directions in jazz after the era of Gillespie and Charlie Parker and feared that jazz had departed from its roots in spirituality, love, and suffering. Increasingly she turned to religious composition, often based in jazz, including *Hymn in Honor of St. Martin de Porres—Black Christ of the Andes*, with a text by Father Anthony Woods. In 1963 she wrote a *Mass* in a jazz-gospel idiom for students at Seton High School in Pittsburgh, and in 1969 she completed the work presented here, *Mary Lou's Mass*. Jazz pianist Marian McPartland points to Mary Lou Williams as a major influence, and Duke Ellington drew inspiration from her turn to sacred music in composing his own. In 1963 Williams gave the new recording of her *Black Christ of the Andes* to Ellington, and in 1965 he embarked upon a series of religious compositions. In 1967, in New York's Carnegie Hall, she presented a concert entitled "Praise the Lord in many voices," to which she contributed three new works.

In later years, Williams became a prominent educator in the Pittsburgh schools, at the University of Massachusetts at Amherst, and finally at Duke University, where she taught jazz history from 1977 until her death. Late in life she would often point out the value of learning through observation: "I watch," she frequently would tell her students. She established her own publishing firm, Cecilia Publishing Company, and founded the recording label Mary Records, the oldest label owned by a black artist. Williams established the Bel Canto Foundation to aid musicians who had become addicted to alcohol or drugs, funding that work through her concerts and royalties. In 1977, in an illustration of her versatility, she appeared at Carnegie Hall twice, once with Swing-era musician Benny Goodman and then with avant-garde jazz pianist Cecil Taylor. She received a Guggenheim Foundation grant for composition and several honorary doctorates, and in 1990 she became the first woman instrumentalist admitted to the *Down Beat* Hall of Fame.

Mary Lou's Mass is Williams's most acclaimed work. It represents an effort of many years, multiple uses, and significant recomposition. Williams wrote *Pater Noster* in 1966; it was performed in 1967 and rewritten in 1969–70. She performed the revision on the Dick Cavitt Show in 1971. The choreographer Alvin Ailey renamed the extended composition, first known as *Music for Peace*, as *Mary Lou's Mass* in 1971, and the title was retained. In the 1970s, Ailey's principal dancer, Judith Jamison, performed several versions of "Our Father" with the Alvin Ailey American Dance Theater and as a solo at the Riverside Church, in New York.

The composition interweaves texts from the Votive Mass for Peace with the ancient Ordinary of the Mass. Williams draws upon elements of both services that hold a particular meaning for her, such as the section "Blessed are the Peacemakers" toward the end, the antiphon said after communion in the Votive Mass for Peace. There are many arrangements of *Mary Lou's Mass*, including one for children's chorus, made in 1975.

This essay and the opportunity to include the following section from *Mary Lou's Mass* are indebted to Peter F. O'Brien, S.J., who was befriended by Mary Lou Williams in the 1960s. He became her general manager and foremost spokesperson, and is the Executive Director of the Mary Lou Williams Foundation. She composed "Blues for Peter" (1965) as a tribute to him.

Our Father

Mary Lou Williams

Printed by permission of Peter F. O'Brien, S.J., Executive Director of the May Lou Williams Foundation, Inc.

Judith Lang Zaimont

(born 1945)

Judith Zaimont was born in Memphis, Tennessee, but was raised in New York. Her family was musical, and she studied piano from 1958 to 1964 at the Juilliard School of Music. Her major teachers of composition were Hugo Weisgall at Queens College, from which she earned a Bachelor of Arts in 1966, and Jack Beeson and Otto Luening at Columbia University, where she received a master's degree in 1968. In 1971–72, she pursued private study with André Jolivet in France. She has held teaching posts at Hunter College, Adelphi University, and Peabody Conservatory in Baltimore; and since 1992 she has been professor of composition at the University of Minnesota at Minneapolis.

Zaimont's earliest recognition came in the 1970s with works for solo voices and chorus: two song cycles, one on Native American texts, *The Magic World*, the other on women poets, *Greyed Sonnets*; and the oratorio *Sacred Service for the Sabbath Evening*. Since 1983, Zaimont has focused increasingly on instrumental composition, such as *Dance/Inner Dance* (1985), for flute, oboe, and cello (which received first prize in the 1990 Friends and Enemies of New Music Competition); and *Symphony No. 1* (winner of the Musical Fund Society Competition of 1994, celebrating the 175th anniversary of the Society), which was premiered by the Philadelphia Orchestra.

Zaimont has received numerous other awards for her compositions from Broadcast Music Inc., National Federation of Music Clubs, Woodrow Wilson and Seidl Fellowships, Presser Foundation, and National League of Pen Women. In 1986, *Chroma-Northern Lights* won first prize in the chamber orchestra contest for a work honoring the Statue of Liberty Centennial. Her works have been performed in Carnegie Hall and Lincoln Center and are recorded on the Arabesque, Leonarda, and Northeastern labels.

Judith Zaimont has been a vital force in the women's music movement as editor, author, and lecturer. She has spoken before the International Music Council of UNESCO, on National Public Radio in the United States, at the National Museum of Women in the Arts in Washington, D.C., and at many colleges and universities. In her most important effort, she founded and edits an acclaimed series of books entitled *The Musical Woman: An International Perspective* (New York: Greenwood Press, three volumes to date). For that contribution she received a grant from the National Endowment for the Humanities and a Pauline Alderman Prize "for broad musical scholarship at its best."

In a personal communication of 1993, Zaimont wrote:

> I grew up without knowing the name of any women who had written music. Music history texts didn't mention them, and they were never spoken of in class, the music went unplayed. Coming to know my female forebears over the last dozen years . . . has meant the world to me. . . . No child of future generations should ever have to experience the slightest hesitancy about pitting his or her talent against the demands of any musical career for lack of documented successful role models. The present era of discovery and dispassionate critical evaluation is far from over.

Regarding personal role models, she said, "Perhaps because of my sister (conductor Doris Kosloff) . . . , and because of my mother (a prominent pianist-teacher) . . . , it didn't seem at all remarkable to be a woman specializing in a career within music." In a communication of December 1995, she wrote that

> composition began spontaneously at age eleven, and soon I knew I was born to write music. There were never any parental arguments against a musical career, only encouragement and championing of my work. . . . I don't see composing as either a female or male act, nor believe that it is capable of analysis in gendered terms. Composers reach their listeners *mind to mind*; as all art, particular musical utterance is the fruit of *individual personality*, period.
>
> As I see it, the only possibly valid gendered aspect of music composition might be women's employing non-standard forms, where the musical associations of part to part are created in "quilt-like" ("inclusive") fashion—perhaps achieved intuitively—rather than the dogmatic working-through of traditional fugue, sonata development, and similar forms. This may be more akin to a novelist's permitting the "character" to indicate "what comes next," rather than imposing a pre-arranged frame or chronology that virtually dictates character development.

The text of *Parable: A Tale of Abram and Isaac* (1986) is derived from three sources: the Brome Mystery Play, the poetry of Wilfred Owen (whose texts are set in Benjamin Britten's *War Requiem*), and the Mourner's Kaddish from the Jewish liturgy. It is scored for soprano, tenor, and baritone soloists, chorus SSATTB, and organ. An alternative version for strings and harpsichord is available through the composer. The Florilegium Chamber Choir commissioned the work, with funding from the New York State Council on the Arts. The premiere took place in Merkin Hall, in New York, in June 1986 in the version with instruments. Conductor Gregg Smith referred to *Parable* as "one of the strongest choral works I've heard for some time. It has all the elements one could wish for. . . ." The review in *The New York Times* found that "Zaimont's *Parable* told the story of Abraham and Isaac with a steamrolling rush of emotion. . . . One admired the unflagging energy of her music."

In her notes on the work, Zaimont deems Owen's text "The Parable of the Old Man and the Young" notable for reinterpreting the Old Testament story of Isaac. The "old men" of Europe seem "permanently programmed" by the Lord's first injunction to sacrifice "the son"—the next generation, who were sacrificed in World War I. She brings to mind her own son, aged five at the time of composition, and expresses the impossibility of coming to terms with sacrificing an innocent young child.

> So, my second task was to find humanizing words . . . words of love and regret (Abram); words of trust, uneasiness, dread (Isaac); words of instruction (the Angel of the Lord [the soprano, who is not heard in this excerpt]). These I discovered in the Brome mystery play, inserted in many places into the Owen [poem]. Once I had opened out

the text, it seemed imperative that the piece had to end with saying Kaddish over Isaac's body.

The piece has three large sections: the Angel's injunction; the journey up the mountainside and conversation between father and son (in which the boy discovers that he is the sacrifice, and which is given in the excerpt below); and finally the rejection of a ram as an alternate sacrifice and the terrible death of Isaac. Zaimont sees the prayer over Isaac as the coda.

The role of the chorus was clear to me, as commentators, narrators, the "Greek chorus. . . ." I created the somewhat tender chord progression that is Isaac's motive and which underlies Abram's "Ariette" in part II, and also determined that the uneasiness of the whole mood would be explored through a half-step fall and rise that is the piece's primary musical material. . . . I consider this work—like my second piano trio, *Zones*, and my *Symphony No. 1*—to be representative because I was moved in the writing of it, and believe I have responded fairly well to my initial creative vision of the piece, both in terms of scope and dimension, and the experience of its content on a moment-to-moment basis.

Discography

"Parable: A Tale of Abram and Isaac (1985)." *Florilegium Chamber Choir*. JoAnn Rice, conductor. Leonarda CD LE 328. Leonarda Productions, Inc., PO Box 1736, Cathedral Station, New York, NY 10025.

Parable: A Tale of Abram and Isaac (excerpt)

Judith Lang Zaimont

401

404